DAVID SKERNICK

BACK ROADS *of the Midwest*

MISSOURI, IOWA, MINNESOTA, WISCONSIN
MICHIGAN, ILLINOIS, INDIANA, OHIO

SCHIFFER PUBLISHING

4880 Lower Valley Road • Atglen, PA 19310

Other Schiffer Books by David Skernick:

Back Roads of the Great Plains,
ISBN 978-0-7643-6186-9

Back Roads of the Pacific Northwest,
ISBN 978-0-7643-6290-3

Back Roads of the Southwest,
ISBN 978-0-7643-5858-6

Copyright © 2022 by David Skernick

Library of Congress Control Number: 2022932085

Designed by Christopher Bower
Cover design by Christopher Bower

Type set in Proxima Nova

ISBN: 978-0-7643-6483-9
Printed in India

Published by Schiffer Publishing, Ltd.
4880 Lower Valley Road
Atglen, PA 19310
Phone: (610) 593-1777; Fax: (610) 593-2002
Email: Info@schifferbooks.com
Web: www.schifferbooks.com

For our complete selection of fine books on this and related subjects, please visit our website at www.schifferbooks.com. You may also write for a free catalog.

Schiffer Publishing's titles are available at special discounts for bulk purchases for sales promotions or premiums. Special editions, including personalized covers, corporate imprints, and excerpts, can be created in large quantities for special needs. For more information, contact the publisher.

DEDICATION

In September 2019, I left for a monthlong photography trip to the Midwest. Four days after I drove away, my dog, Chewy, passed away suddenly. He was eleven years old. That's up there for a German shepherd, especially one who had a rough beginning. Abandoned on the streets of Los Angeles as a puppy, he was dying of the parvovirus when West Side German Shepherd Rescue (a fantastic group of people) found him. I was fortunate enough to adopt him when he was only four months old. My wife, Ria, and our other dog, Dudley, were with him when he died. I was not . . . you dog owners know how I feel. I'm dedicating this book to Chewy—an incredibly sweet, smart, beautiful, wonderful, affectionate, loyal friend. He was a good, good boy.

EPIGRAPH

The country I come from is called the Midwest.

—Bob Dylan

FOREWORD

David and I have known each other since high school. He was as remarkable a photographer then as he is now. With the advent of digital cameras and editing tools, his work has evolved into exquisite panoramic displays of Americana.

His expansive photographs depict seemingly endless prairies and big skies, eliciting a memory of the smell of wheat fields; fresh, unfettered air; laundry on the line out back behind a farmhouse.

David might drive for a hundred miles without seeing anything photo-worthy and then catch sight of a cloud formation. With a gravel-spewing stop and turn of the wheel, he returns, quickly assessing what lens to use, settings, light, exposure, depth of field. Then he waits for the perfect moment, even if it takes hours. Either way, he has an innate sense of when to depress the shutter release.

Art reflects the soul. We all have that need for connection—a desire to share our experiences by creating something. Through art we conquer fears, work through tough life passages, or reach incredible highs. The pandemic has forced us into a more introspective look at what is truly important, and through David's work we find solace on these gray midwestern roads that unspool beneath broad skies.

David's work takes us on a journey of life that not only soothes the artistic soul but give us pause for thought. His countryside represents the bones of where we truly live, and the images he captures elicit curiosity. I want to know how he found that shot, how he set it up, whom he talked to, or how long he waited for the cloud formation to cast just the right shadows on the structures below. Or—also like David—how he convinced an animal to stay still (and not charge him) while he photographed it.

When he and I spoke recently, I asked him about the loneliness of the road, and he left me with this message: To be true to oneself, there must be complete and total autonomy.

David is a true traveler, never lonely. There is always something to engage his heart and soul, and thankfully we can find ourselves with him through his keen photographic eye.

—Ellen Bennett

INTRODUCTION

I have always said that if you were to drop me into the middle of any US state, I could tell you where I am. Each state has a specific look that I find to be easily recognizable. Arizona and Utah each have red rocks, but they are different from each other. Colorado has the Rocky Mountains, and so on. Although the midwestern states have a certain sameness—it is difficult to tell one lake or river from another—I could still tell you what state I am in. Iowa has unique rolling hills, Minnesota has a million lakes, Indiana has lines of trees around the fields that give the landscape a furry look. Illinois is so flat and unremarkable that it becomes remarkable. I love the Midwest. I grew up there, and it feels like home. You always know where you are when you are home.

My books are not meant to be exhaustive collections of photographs from each region. They are more a collection of places and things I see as I drive along. I travel 50,000 miles or so every year along the back roads of the United States. Cities and freeways hold little interest for me. I call this getting lost on "gray roads."

As I crisscross the back roads, I find little gems and prizes everywhere. If you are looking for your favorite spot or road, I may not have found it yet. I will keep looking, and you are, of course, welcome to contact me and make suggestions. I would love to hear from you. Lots of my favorite places were found when I asked someone at a gas station or restaurant, "What's good to see around here?"

Many of my photographs reveal another kind of freedom: panoramic photographs. As a photographer, I was trained in the art of seeing things through the confined dimensions of a 35mm piece of film, approximately 3:2, slightly wider than tall. As all photographers have done, I have worked within these boundaries using wide-angle lenses to capture more of the scene than would otherwise be possible, but the resulting distortion of distance and perspective never felt quite right. I found myself secretly envious of painters, who could select any size of canvas on which to create art. When I discovered panoramic photography, I realized I had found my unrestrained canvas. Panorama photographs

are carefully crafted from multiple photographs that are combined to form one large image. With panoramas, I can photograph without traditional framing limitations. This is immensely satisfying, since I feel that panoramas are best able to convey what you would have seen had you been standing there beside me when I took the picture.

I genuinely enjoyed working on this book. What I do—call it environmental photography—is kind of a treasure hunt. In states such as Utah, Colorado, and California it is kind of like a treasure hunt in a bank! In midwestern states the treasures are fewer and farther between. Some days I might drive 200 to 300 miles between photographs. Of course, that means that when I do find a photo op, it is like finding gold.

The people are terrific too. They invite you onto their property instead of accusing you of trespassing. Look for Gordon's porch in Ohio. He was outside watering his lawn when I passed by a couple of times before getting up the nerve to stop and ask if I could photograph his house. He did not exactly get why I wanted a picture of his porch for this book, but he shrugged and said, "Sure, have at it!" He even moved the hose for me. The folks at the Hangar Kafe in Missouri offered me lunch even after I climbed up on one of their tables with my tripod to make my panoramic photo.

Two different people told me about the swinging bridge in Missouri. I believe either one of them would have dropped what they were doing to drive me there if I had asked. Dana, a ranger at Prairie State Park, helped me find the tiny frog in this book and has become a friend with whom I am still communicating. The fisherman in the boat I photographed in Iowa held still when I yelled to ask, and emailed me later to see the photo. Keith and Sue opened their bar early so I could photograph it, and were then willing to pose for the photo. I could go on. Every picture may tell a story, but there is also a story behind many photos. If you see Bob the Truck on the road, wave me down. I will be happy to hang out and swap a few stories with you.

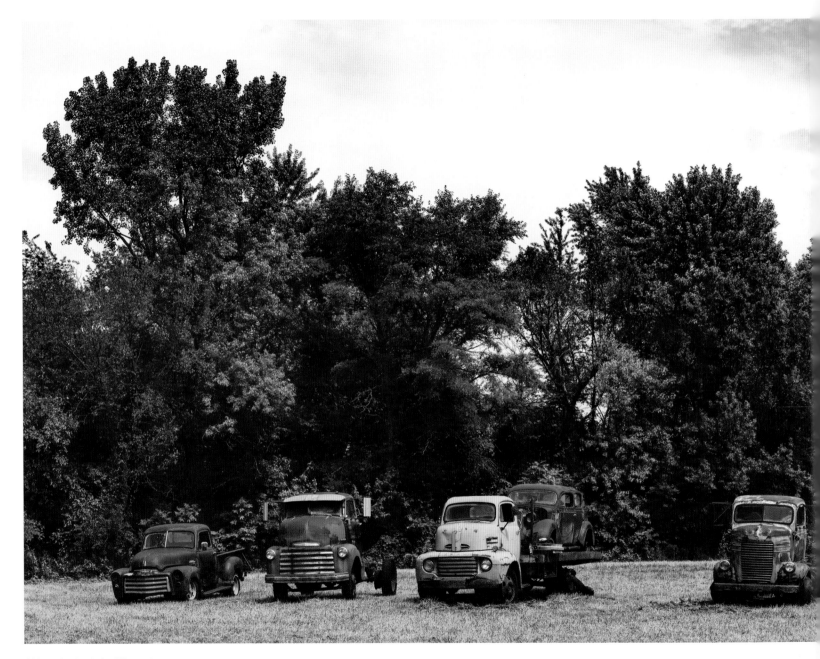

Old trucks, Laclede, Missouri

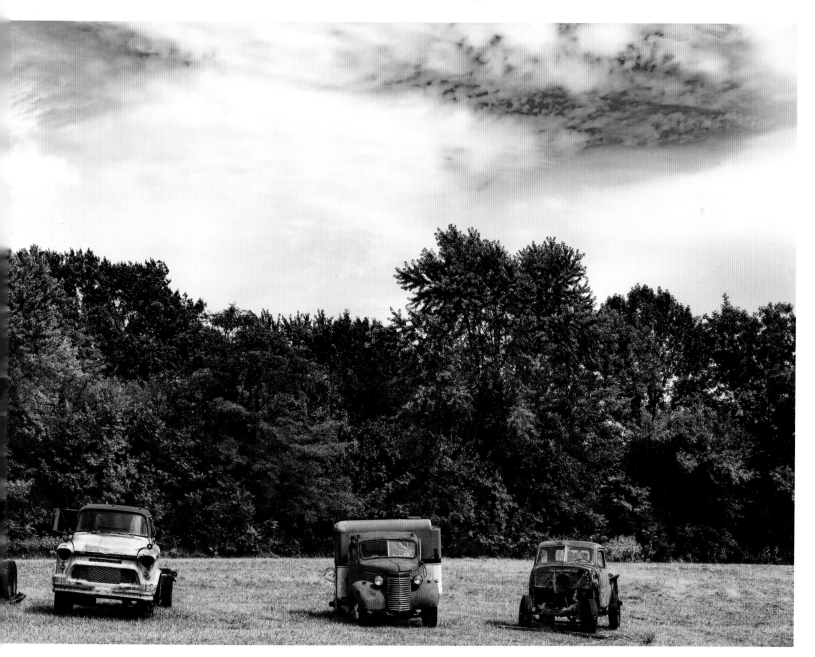

I sometimes find collections like this. These trucks were obviously on display, but there was no explanation or sign of ownership.

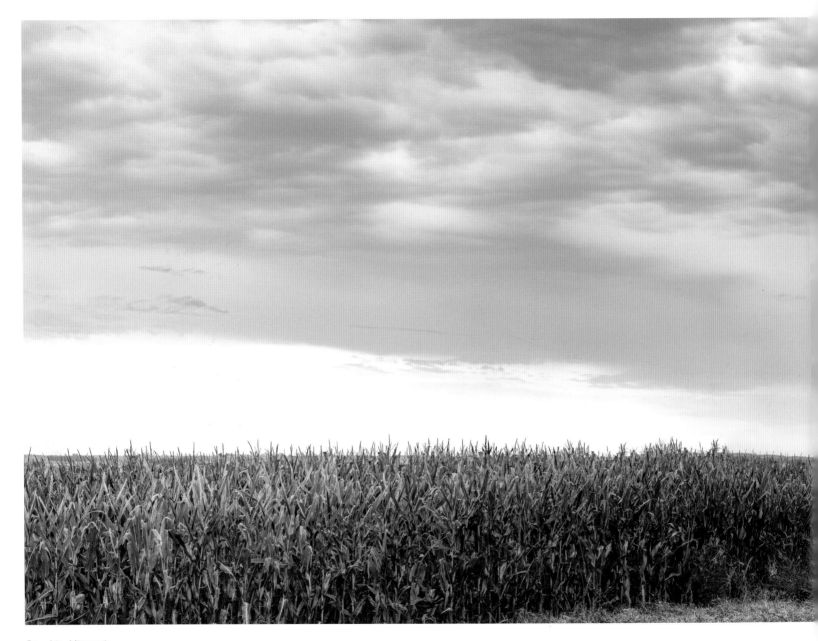

Corn bin, Missouri

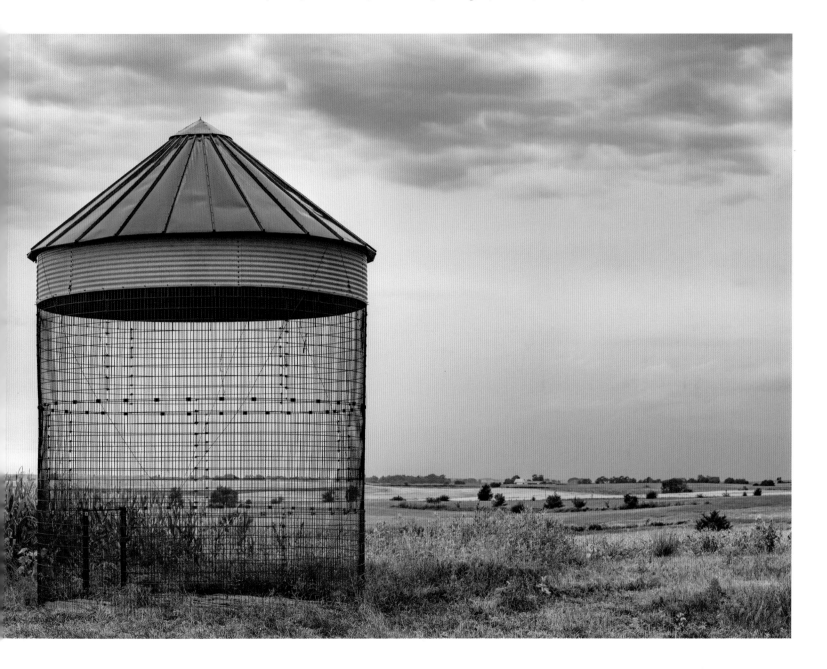

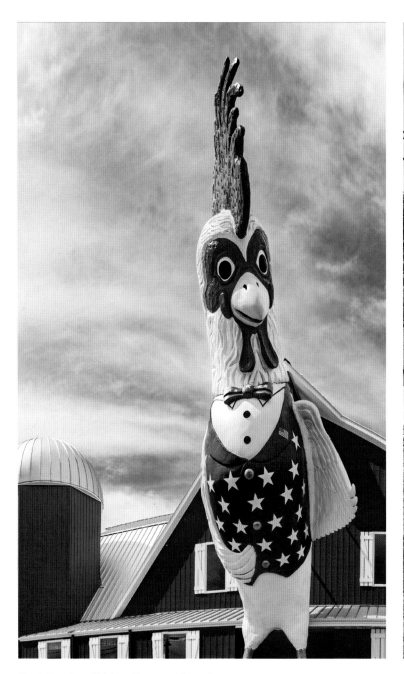

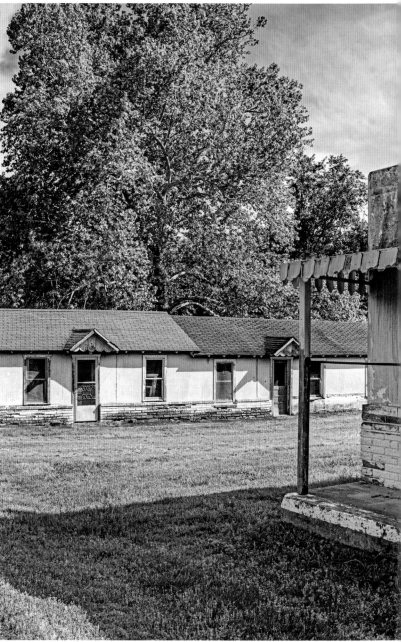

Great American Chicken, Branson, Missouri

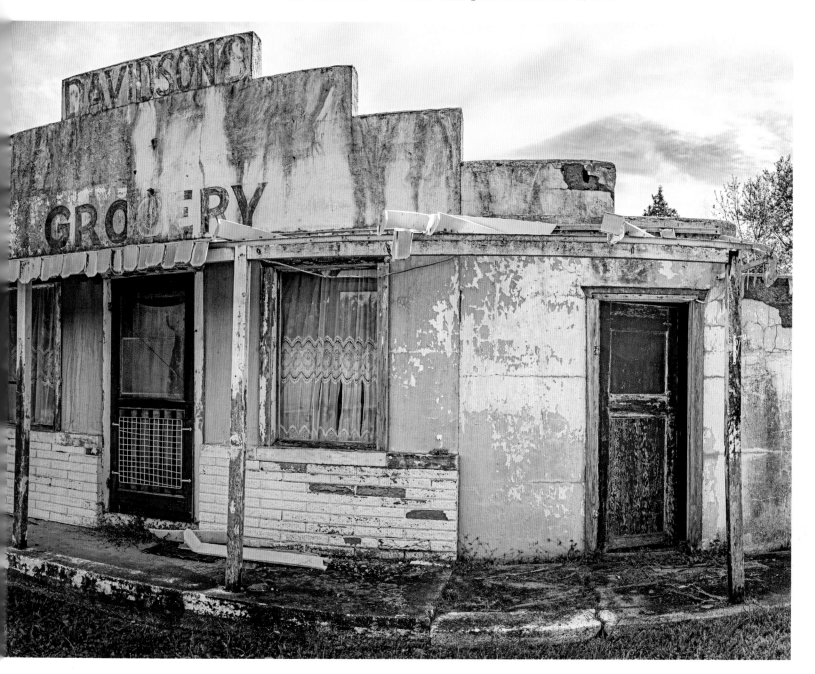

Davidson Grocery, Missouri State Highway 160

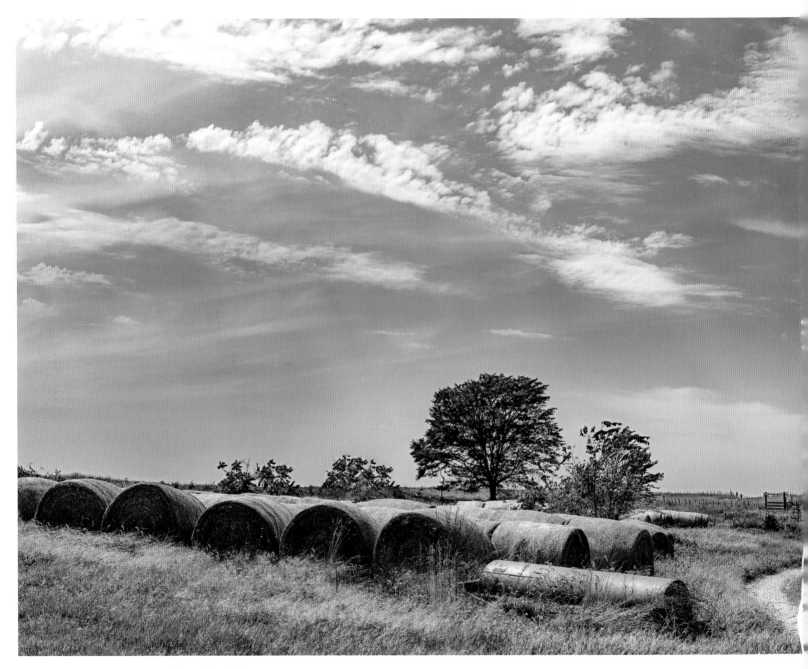

Hay rolls and barn along Missouri County Road BB

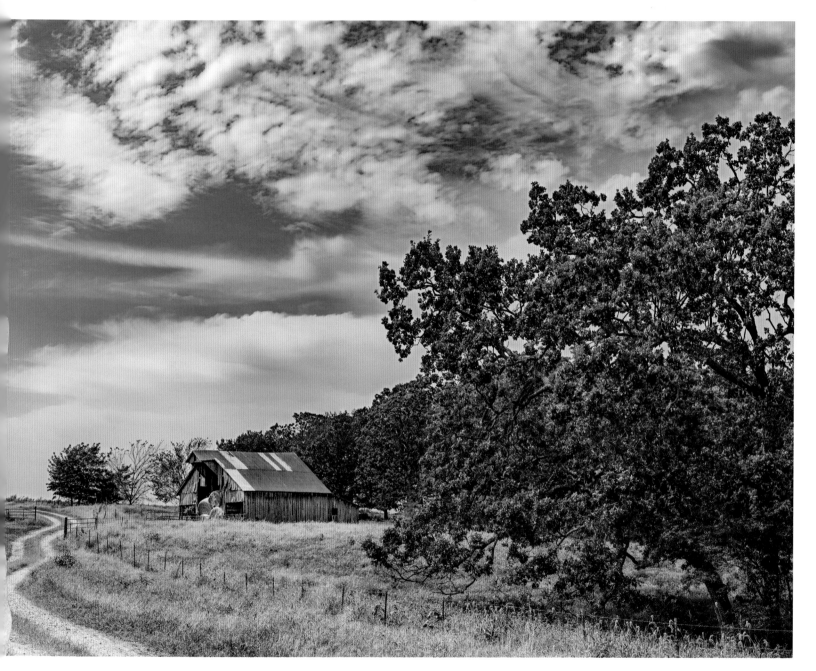

In Missouri, they often use letters for state and county roads. It's one of the ways you know you are in Missouri.

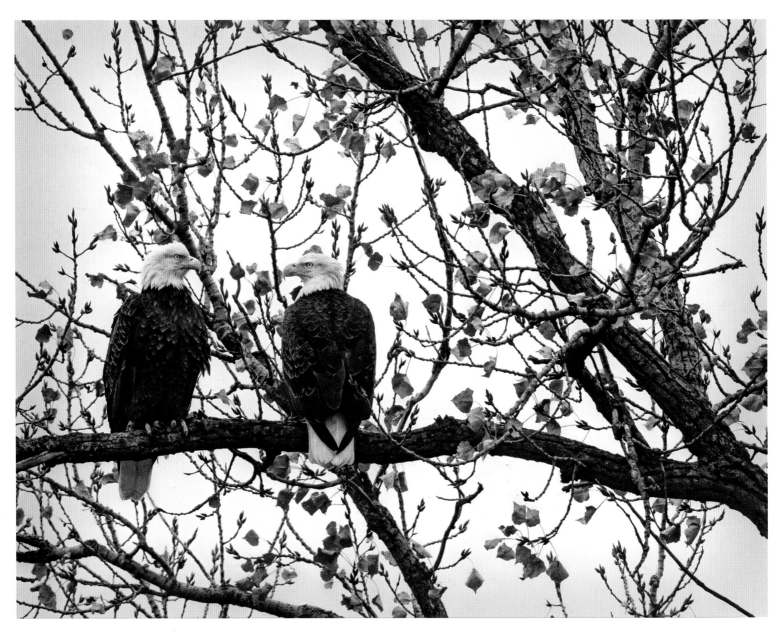

Bald eagles, Missouri

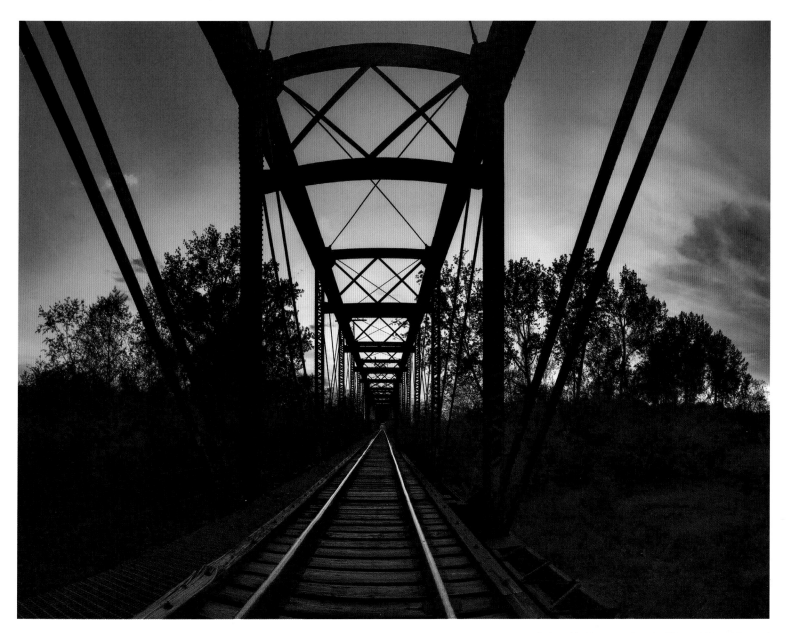

Railroad bridge crossing the Missouri River, Missouri

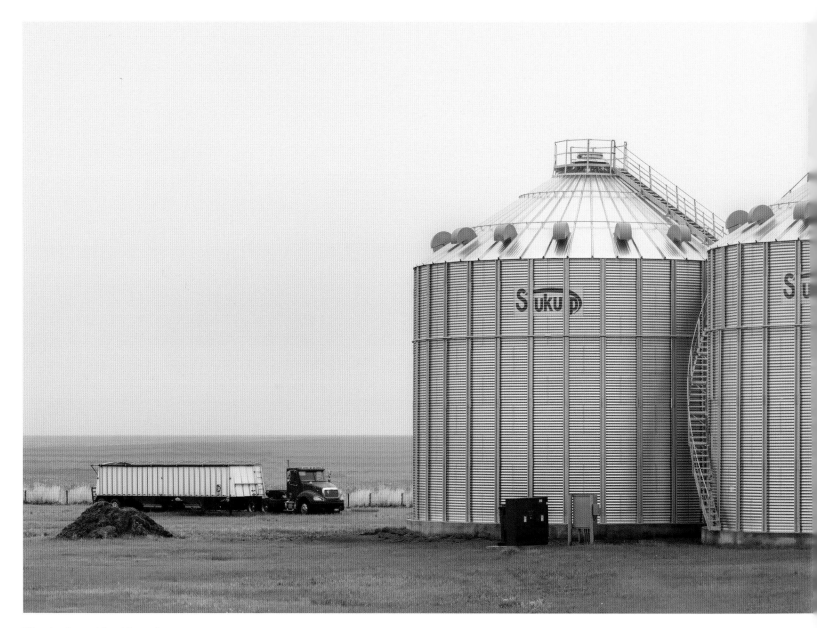

Silos, trucks, and fog, Missouri

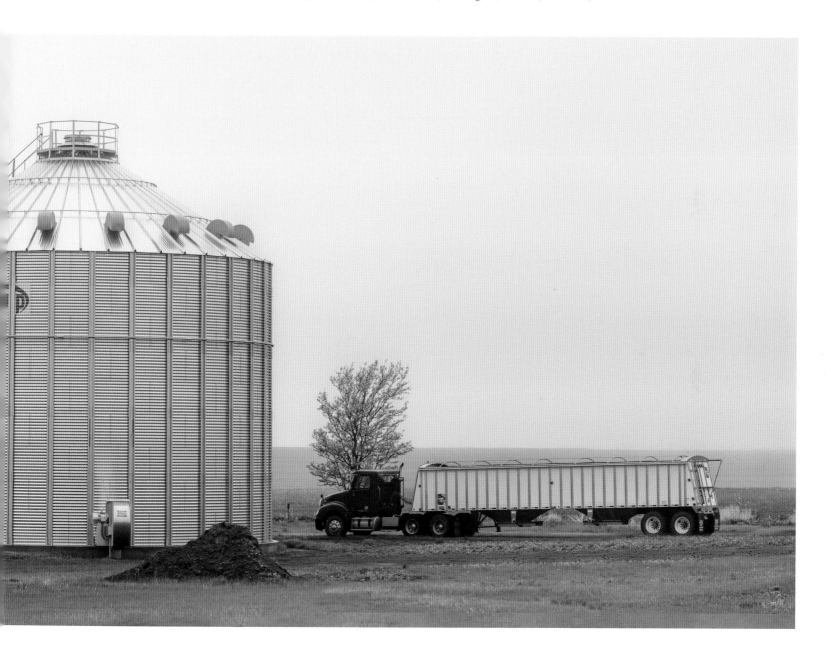

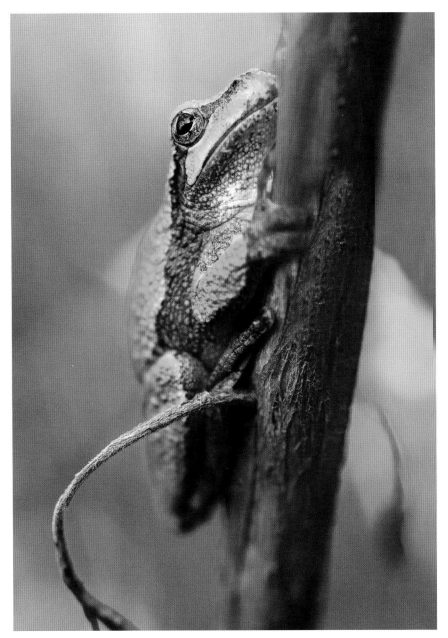

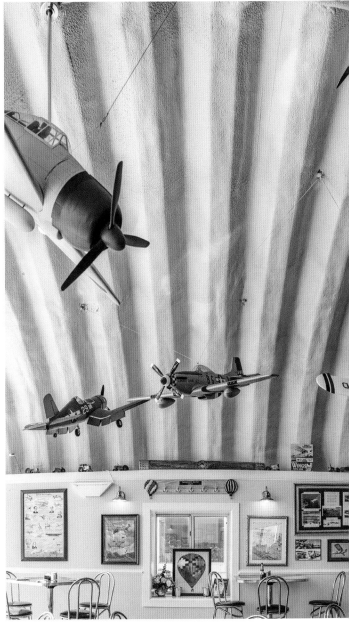

Tree frog, Prairie State Park, Missouri

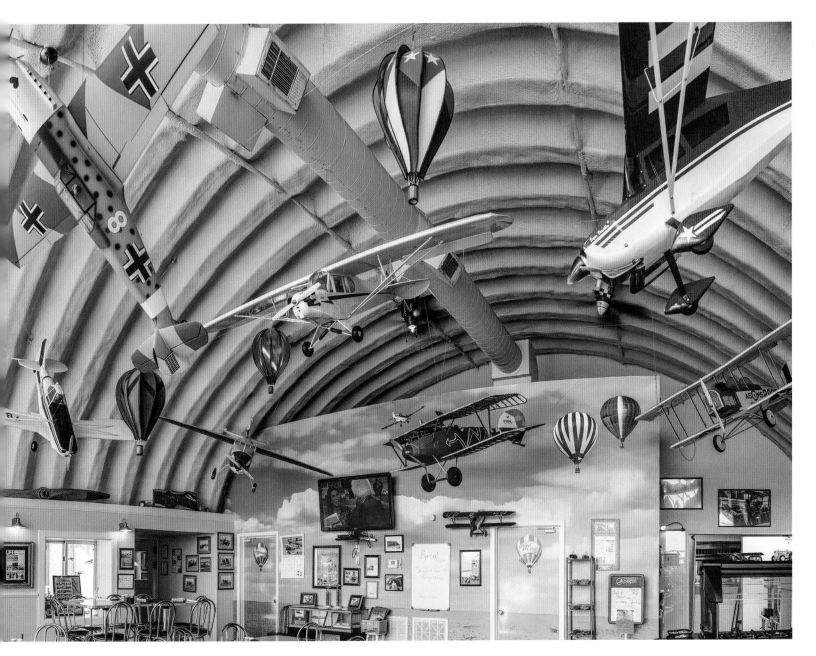

Hangar Kafe, Miller, Missouri
Great food too!

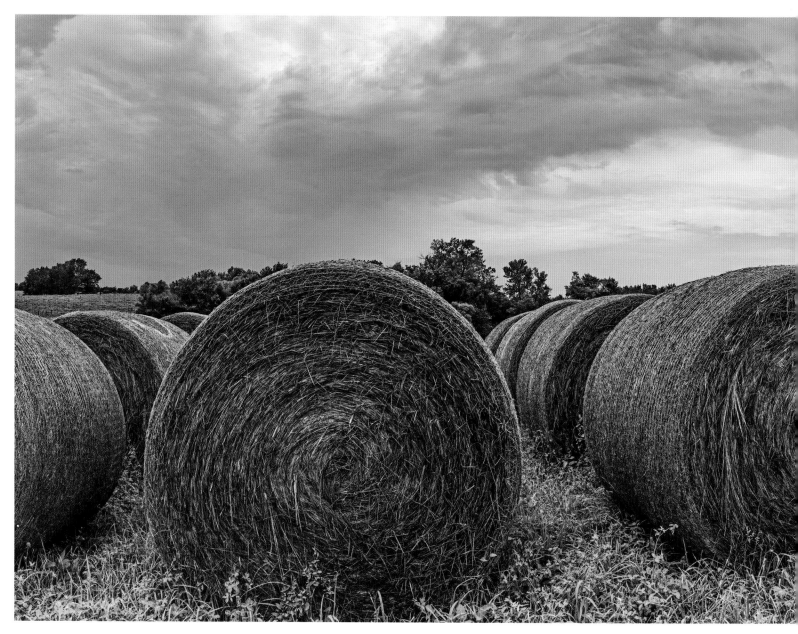

Miller Farms, Missouri

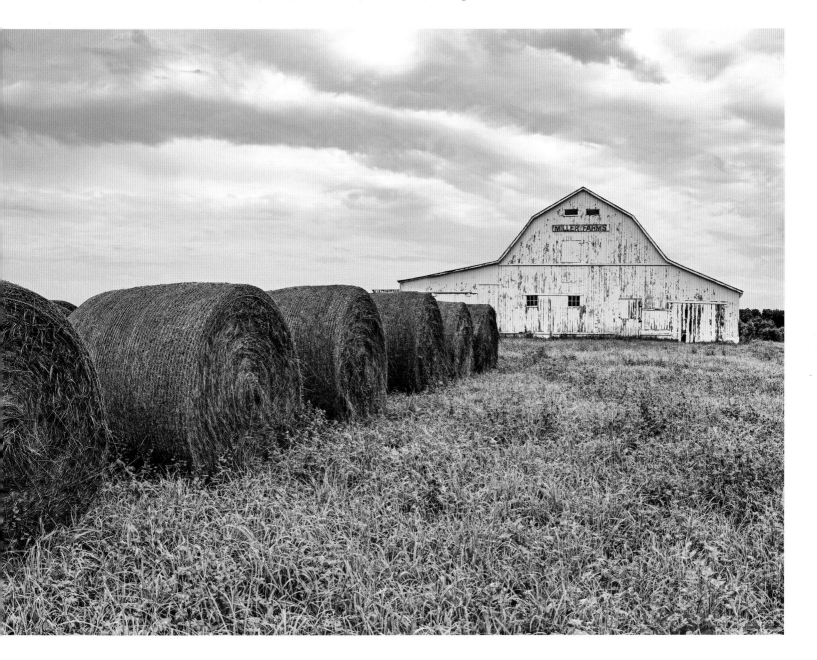

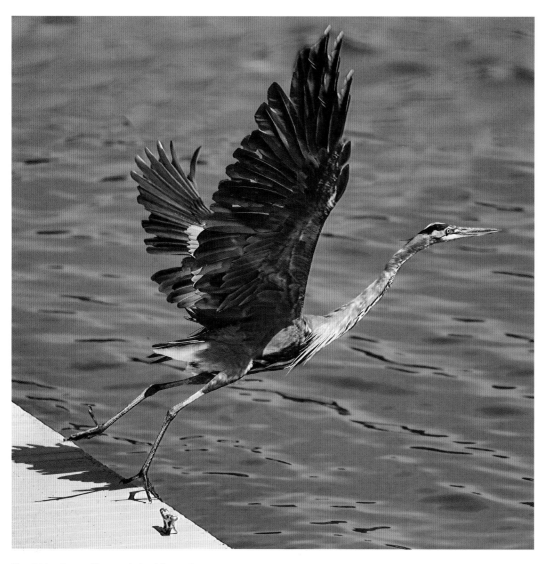

Great blue heron, Truman Lake, Missouri

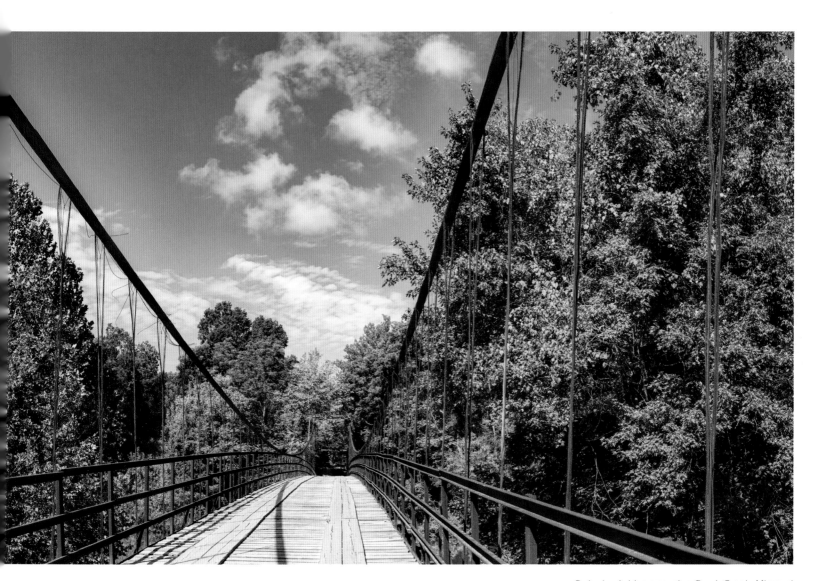

Swinging bridge spanning Ozark Creek, Missouri

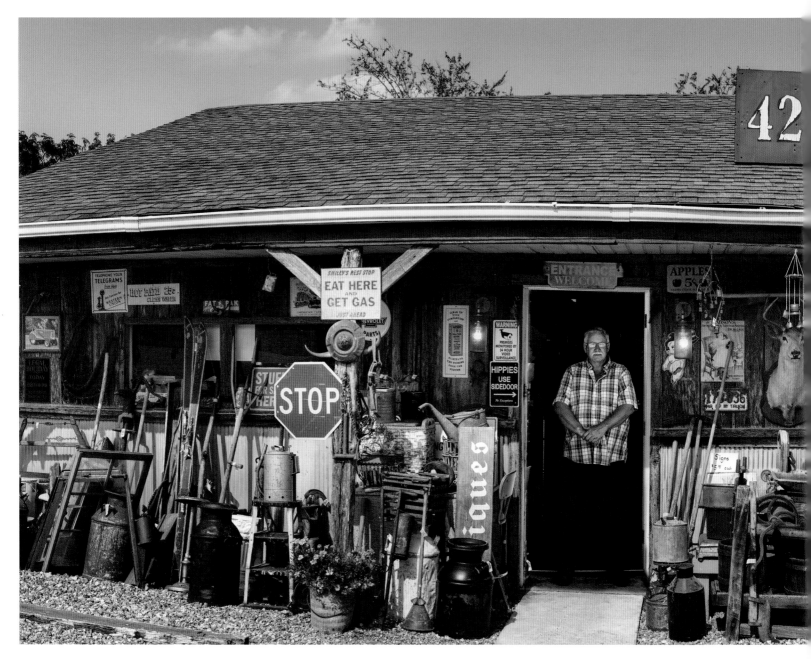

42 Swap Shop and Earl, Brumley, Missouri

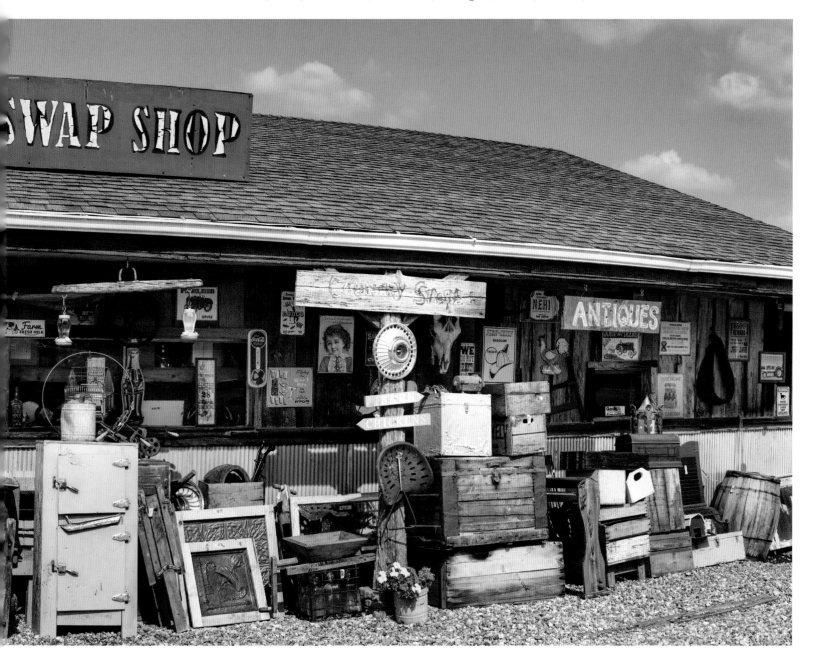

Earl said I could use the photo only if he was in it.

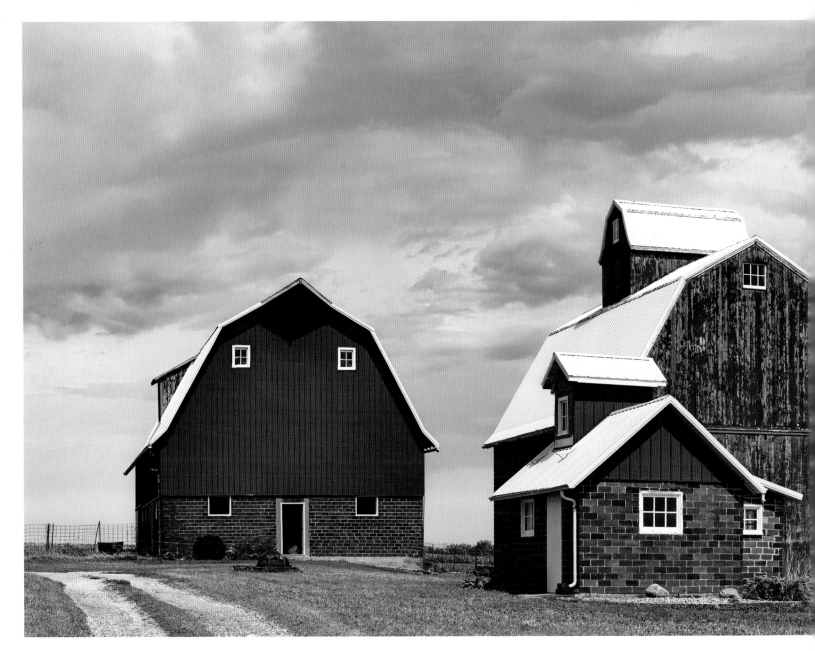

Four barns, Zearing, Iowa

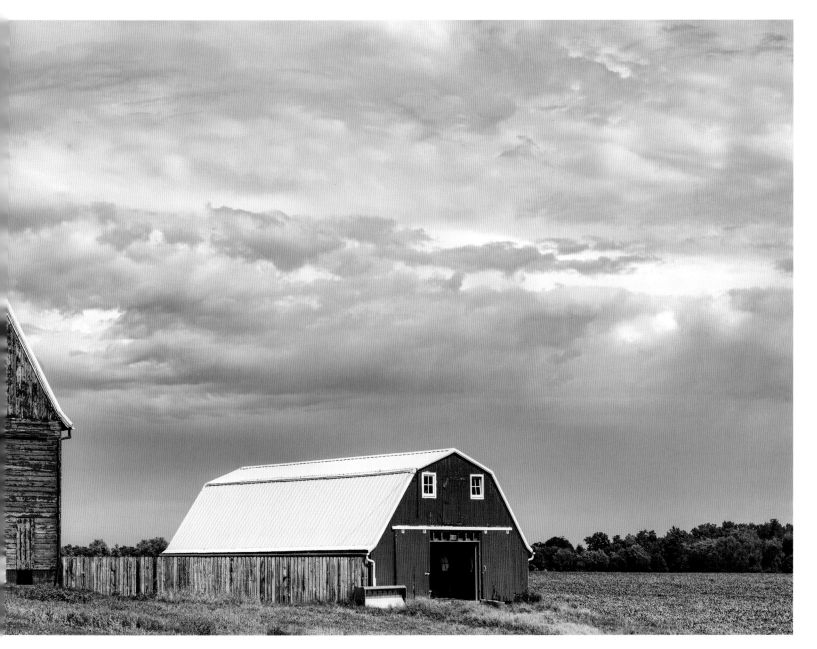

Bonus points if you can spot the golden retriever watching me take this photograph.

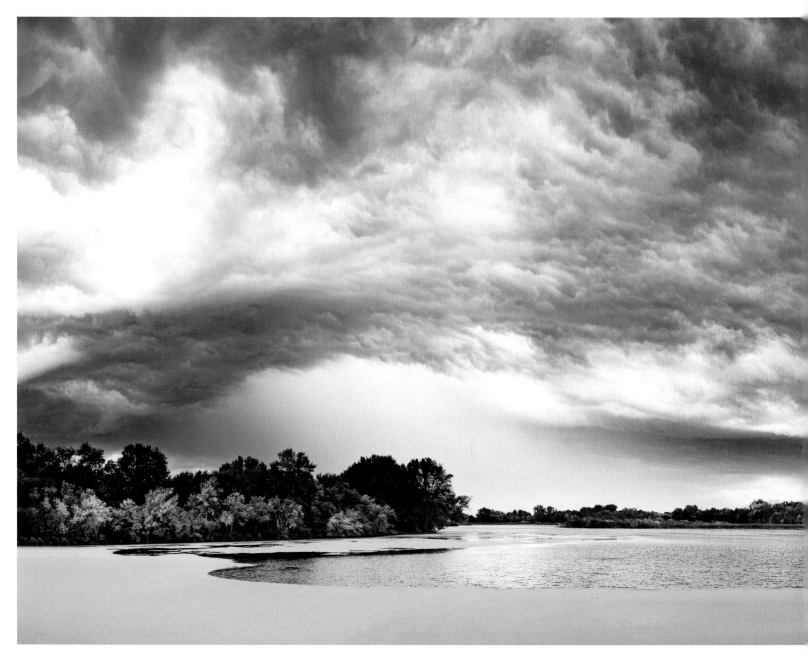

Black Hawk Lake, Iowa

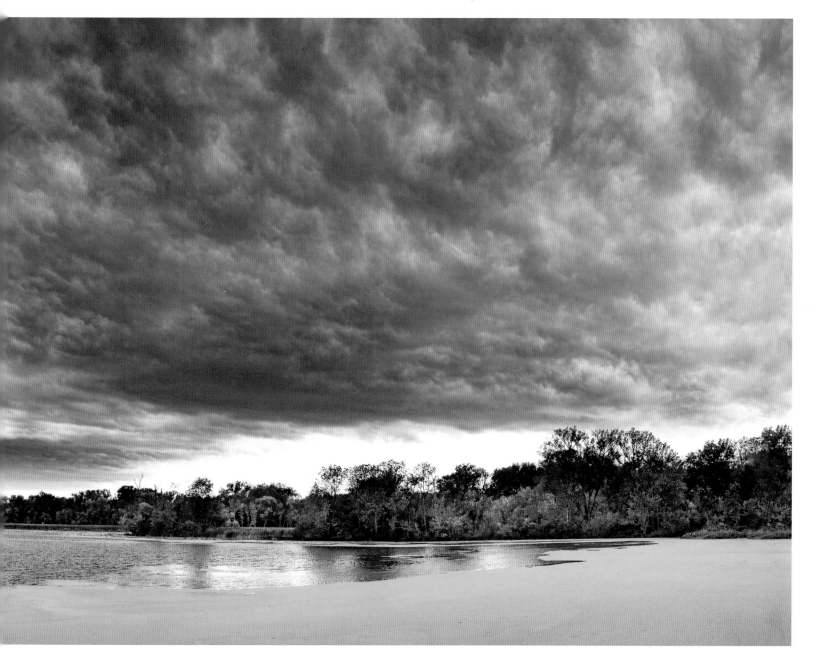

I looked it up. This stuff is called "blue-green algae." The hailstorm that started seconds later was just as amazing.

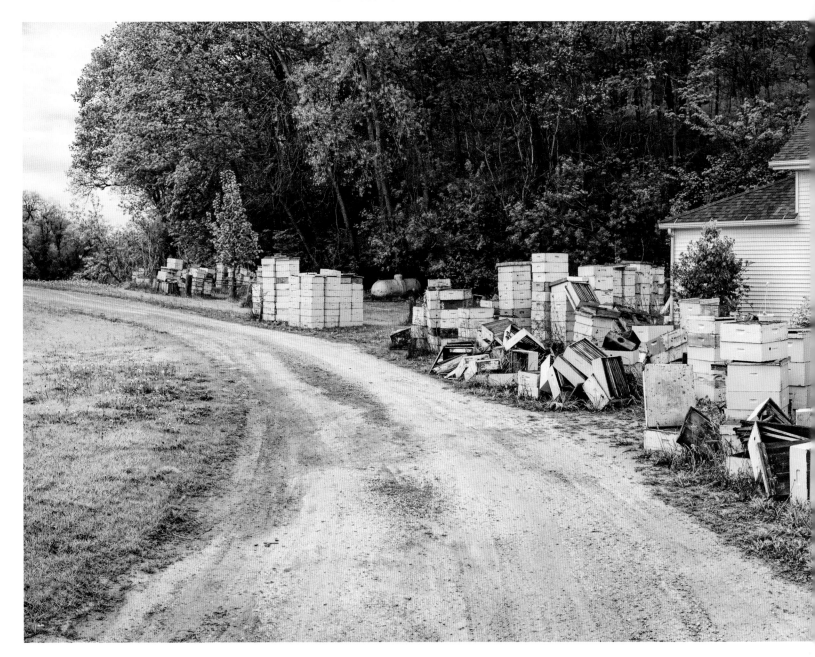

Graham Road, Iowa

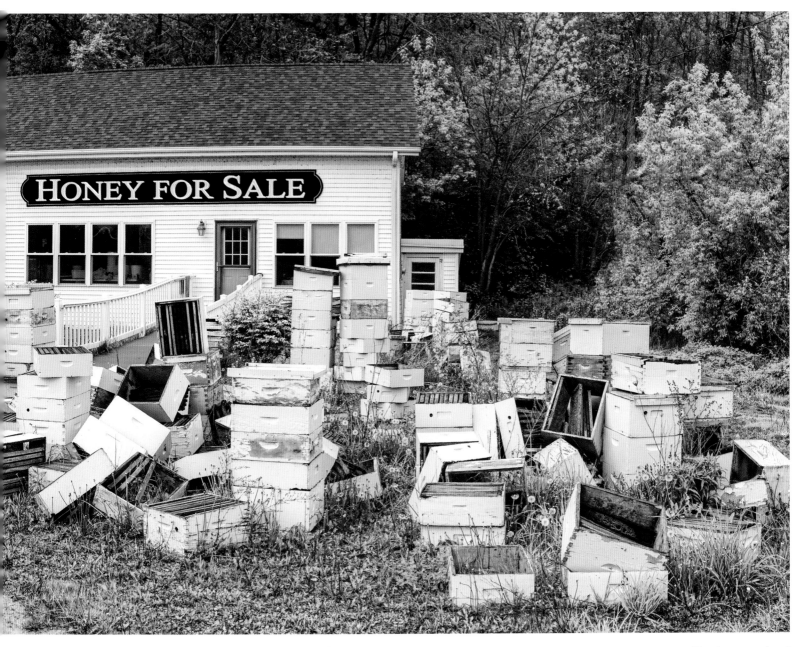

Yes, there were bees!

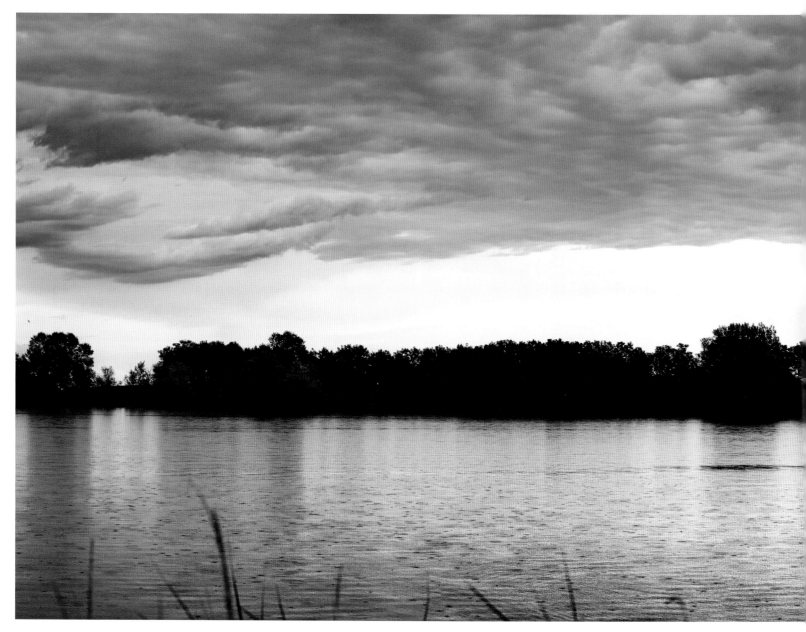

Wall Lake, Iowa

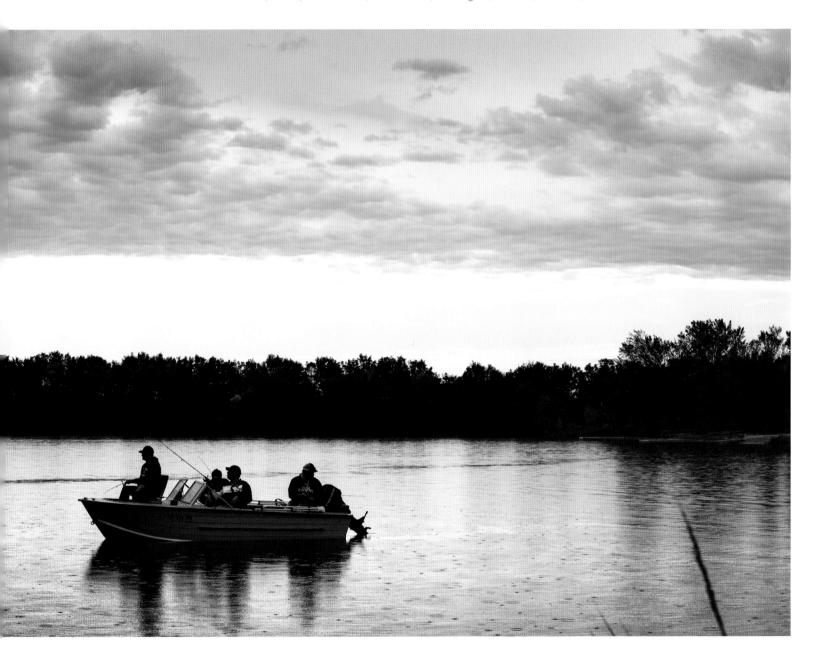

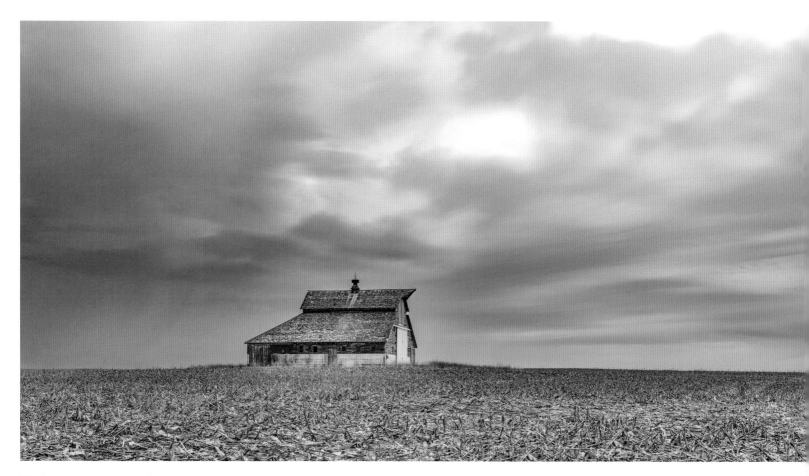

Windswept barn along Iowa State Highway 3

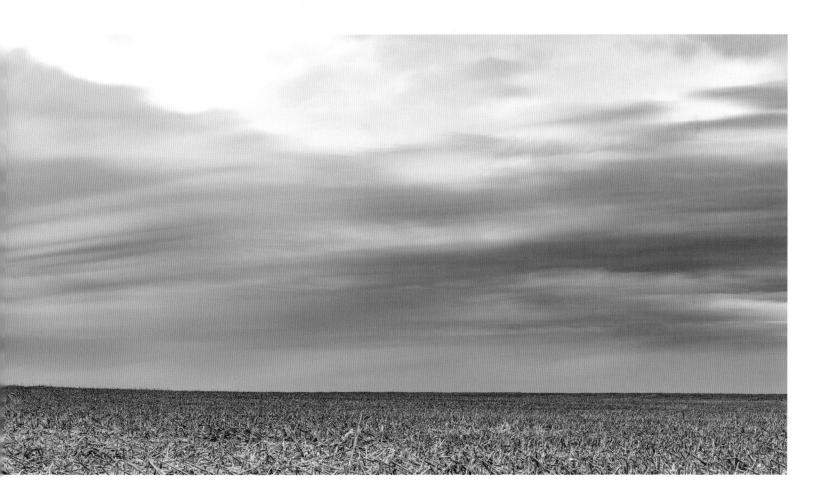

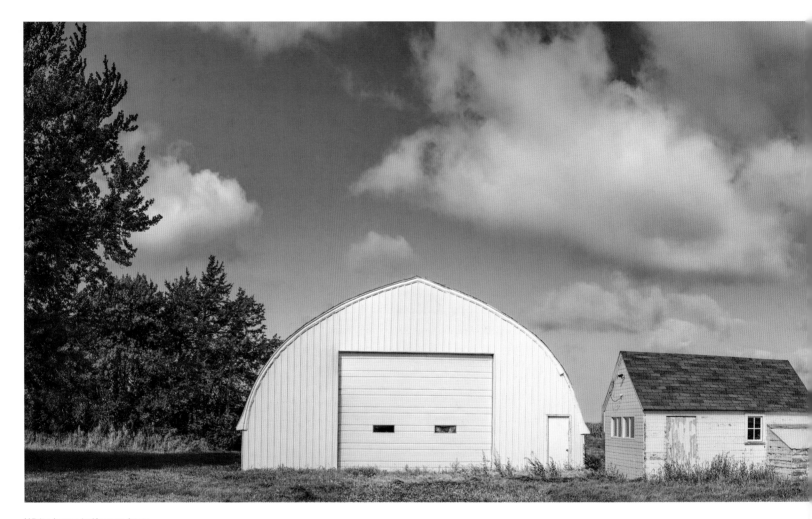

White barns in Kamrar, Iowa

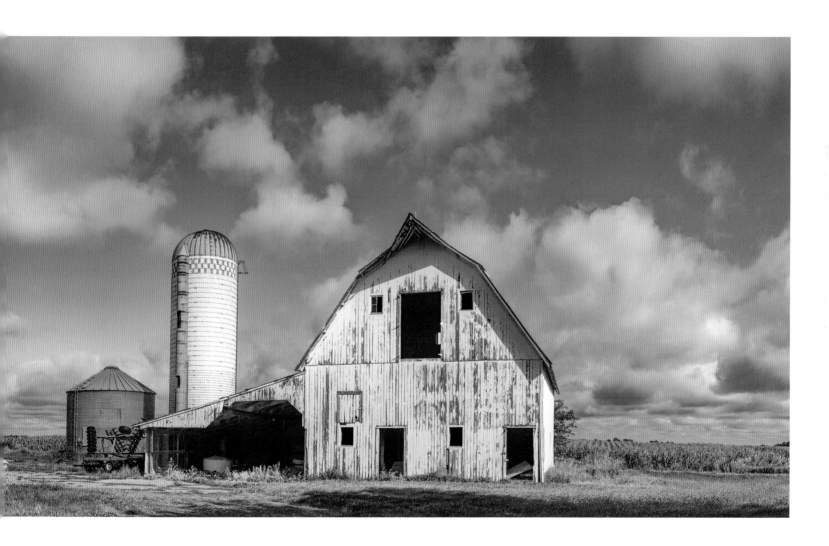

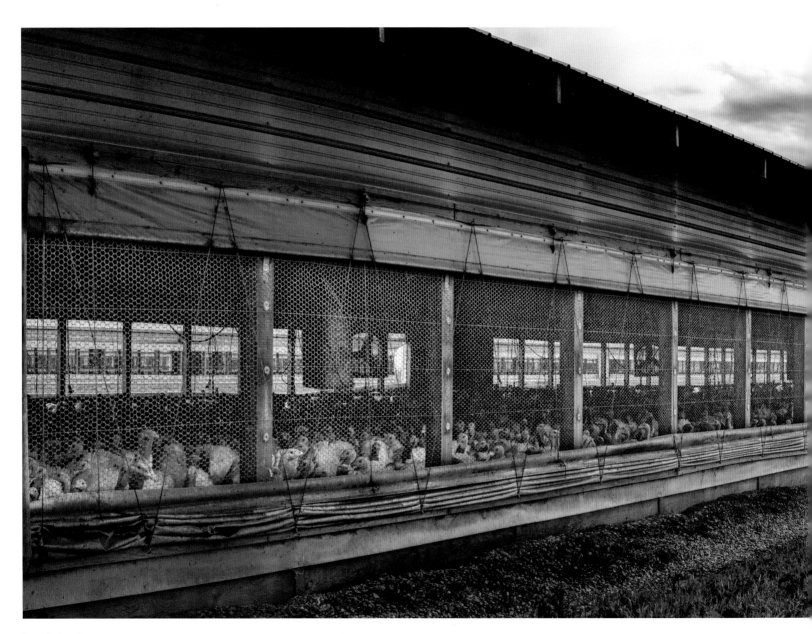

Iowa turkey farm

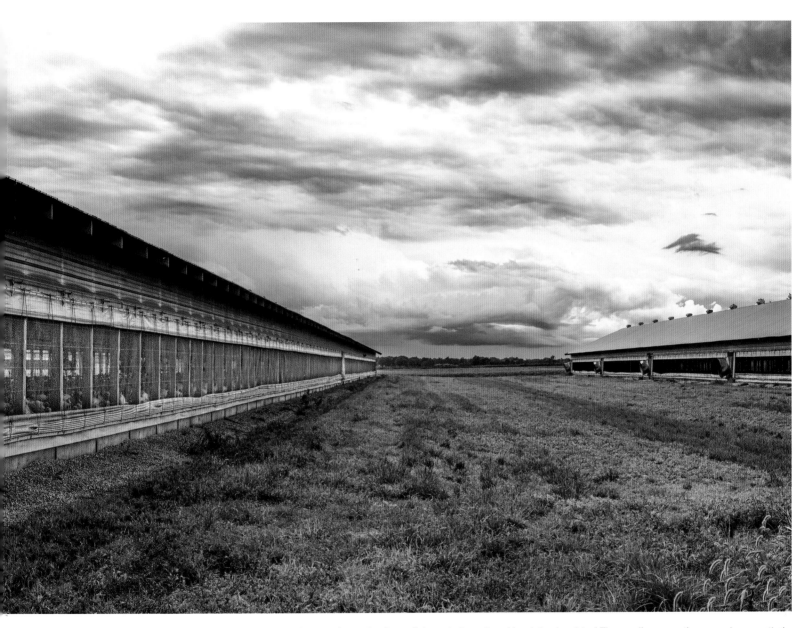

I wish you could have heard the sounds coming from all those turkeys. I could not stop laughing! The smell was another experience entirely.

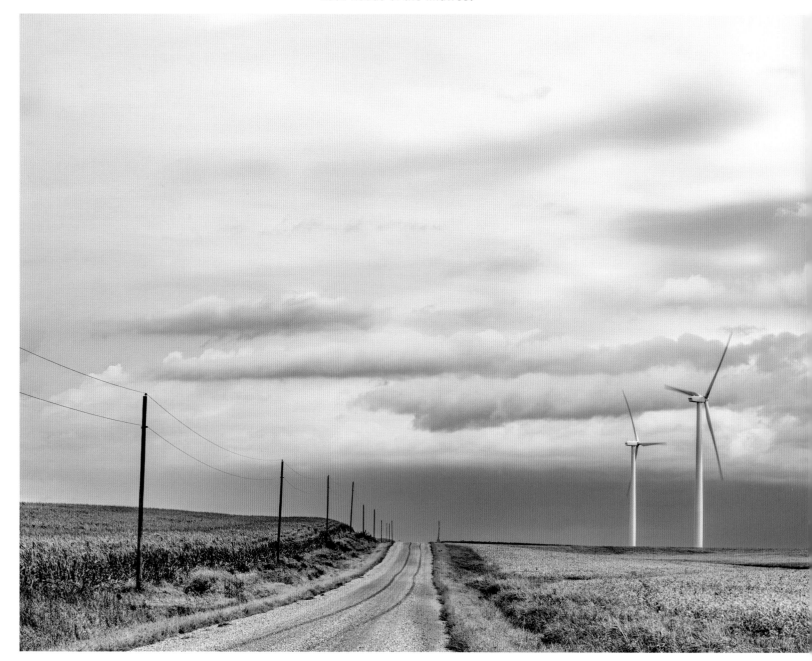

Crystal Avenue, Arcadia, Iowa

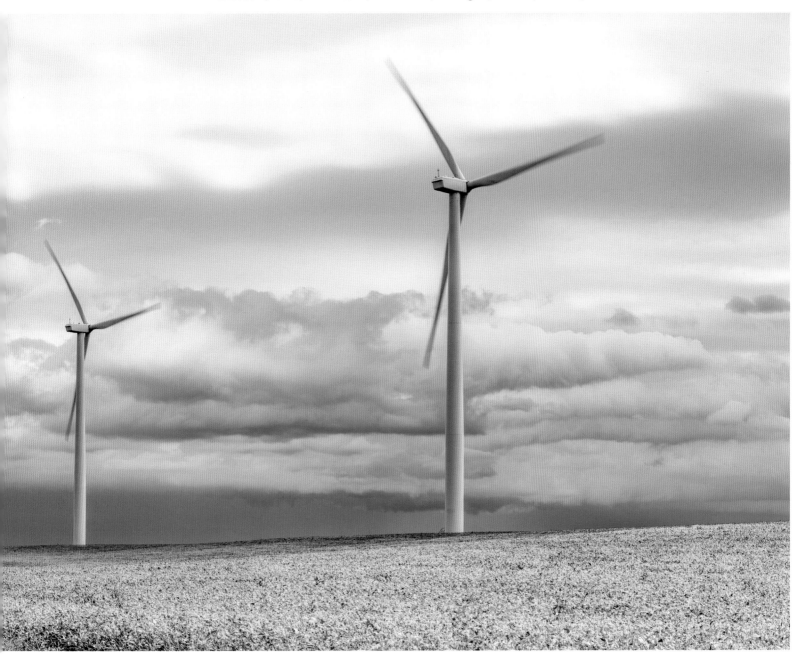

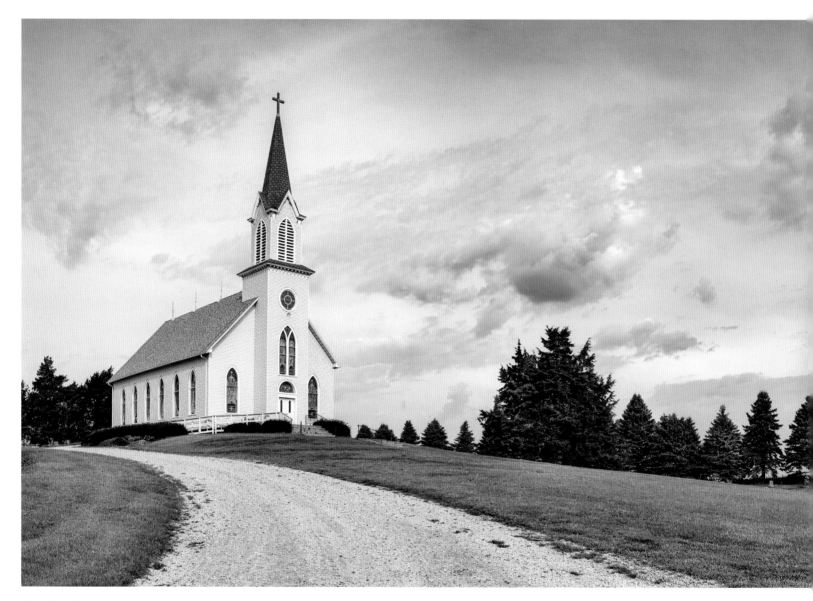

Saint Paul's Lutheran Church, Boone, Iowa

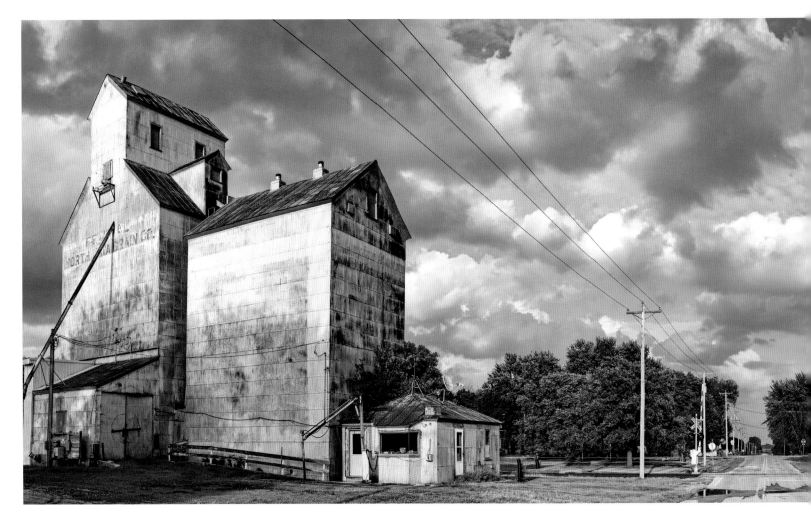

Two granaries, Nevada, Iowa

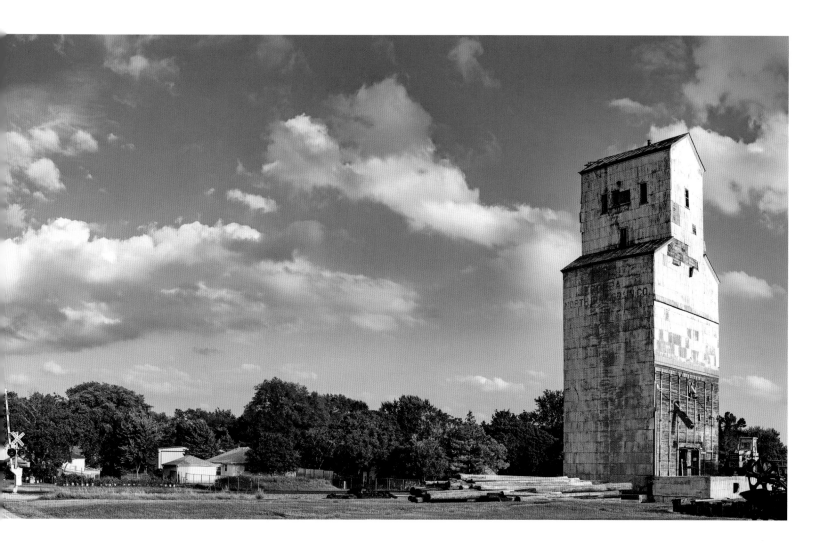

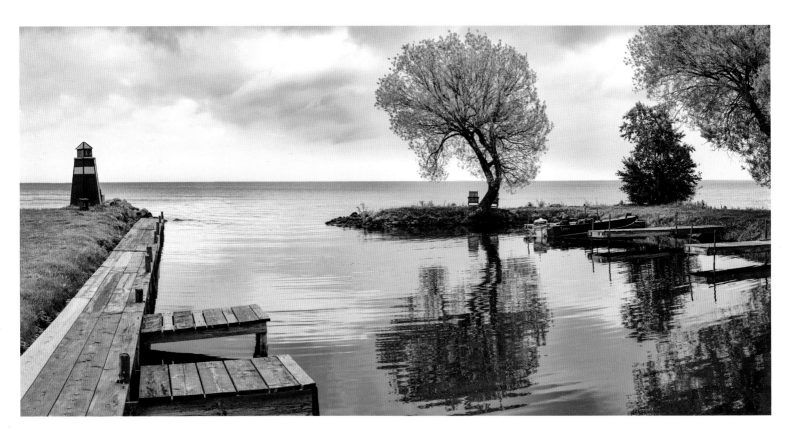

Mille Lacs Lake, Minnesota

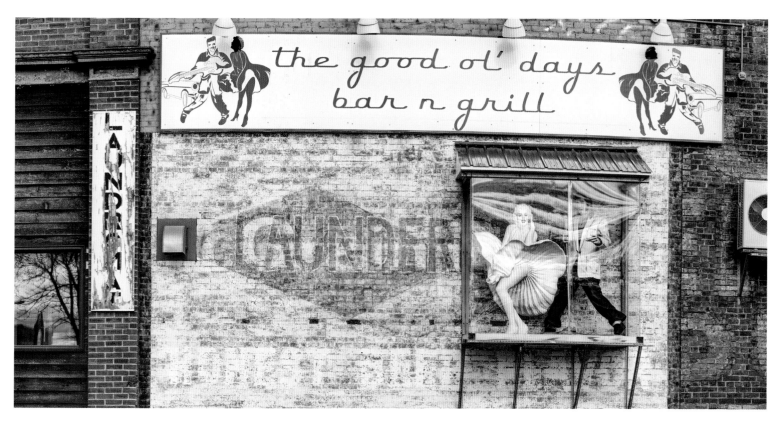

Good Ol' Days Bar and Grill, Tower, Minnesota

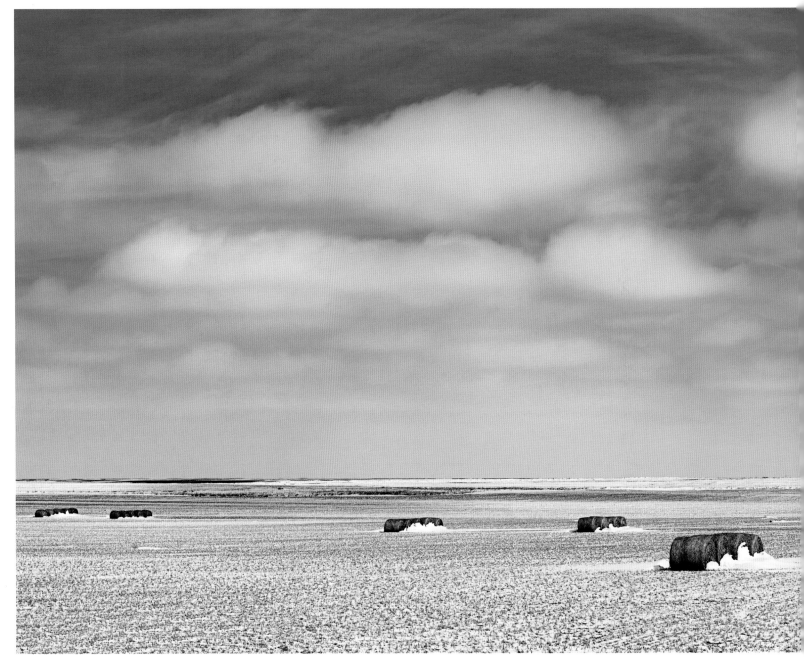

Early snow, Minnesota

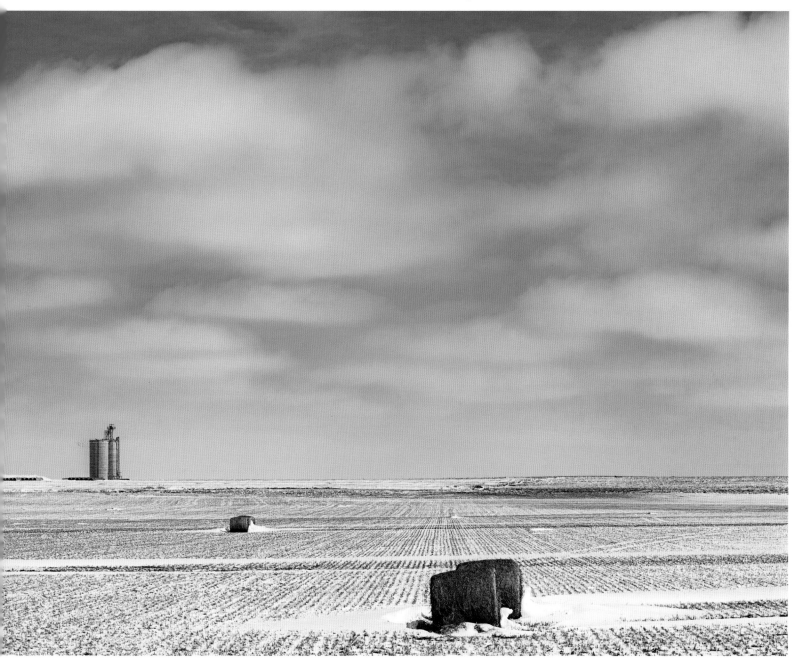

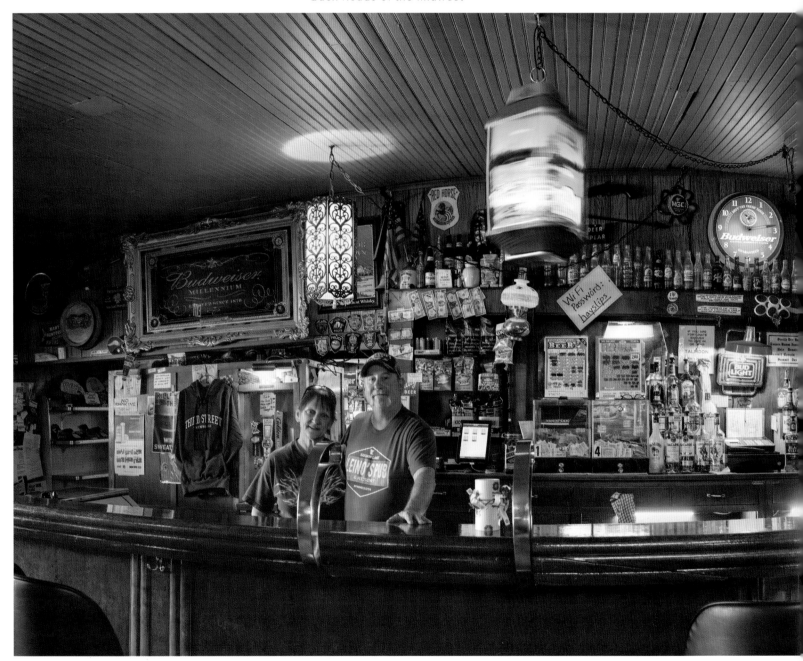

Hayslips Corner Bar, Talmoon, Minnesota, with owners Keith and Sue

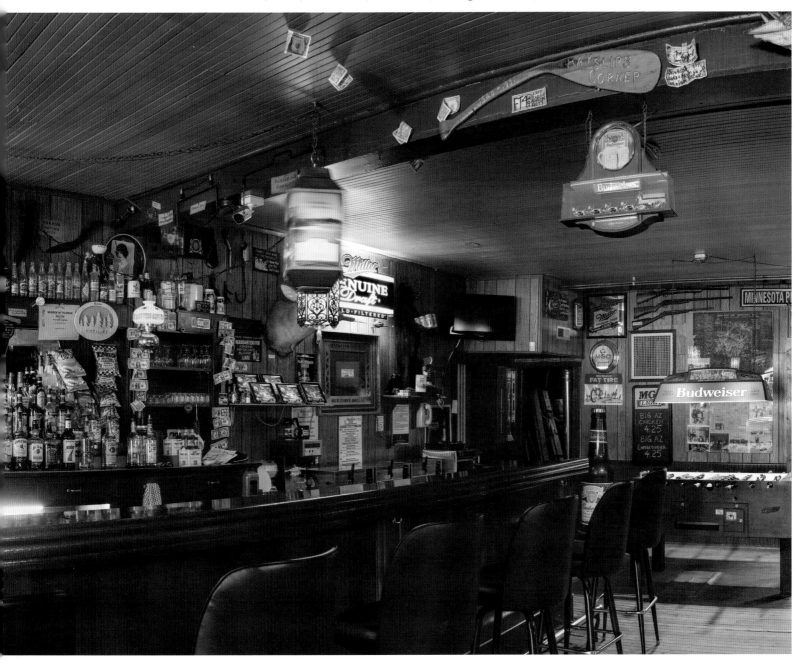

This bar counter is the oldest in Minnesota. Made in Duluth, it was the first off the production line after Prohibition.

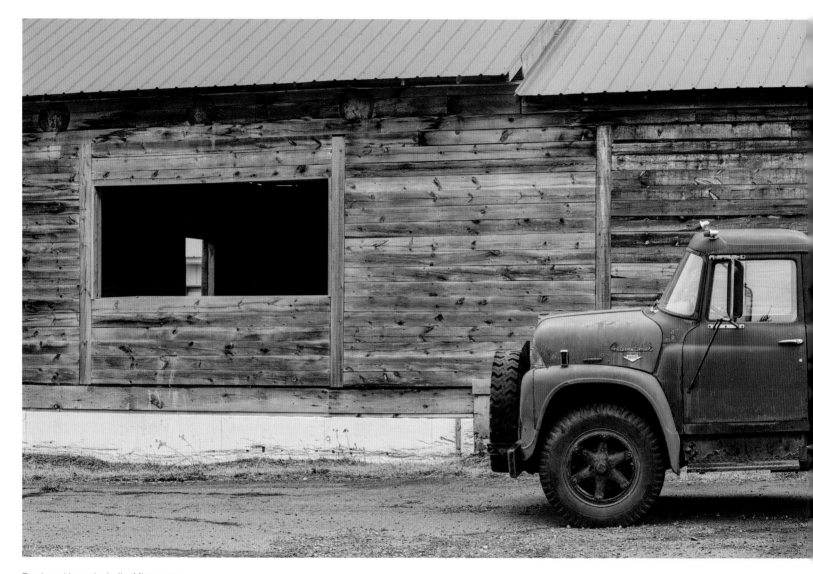

Truck and barn, Isabella, Minnesota

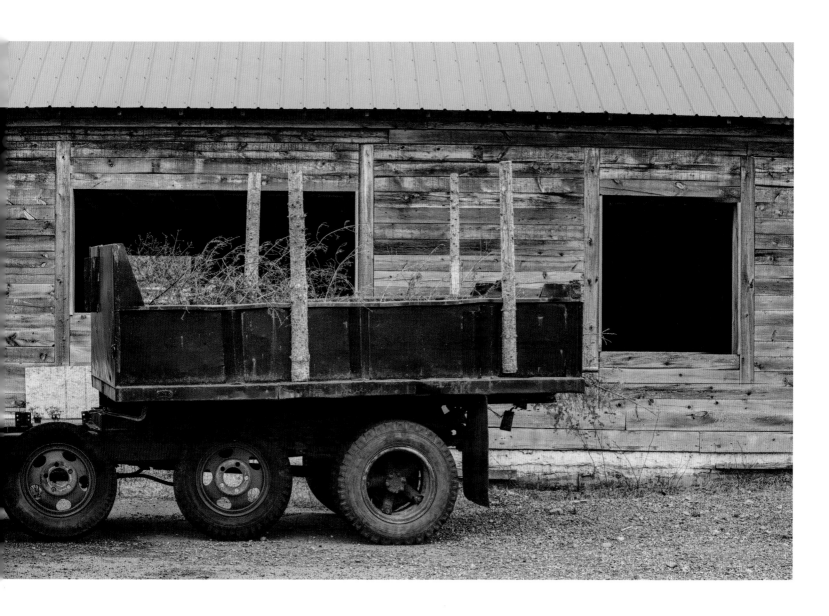

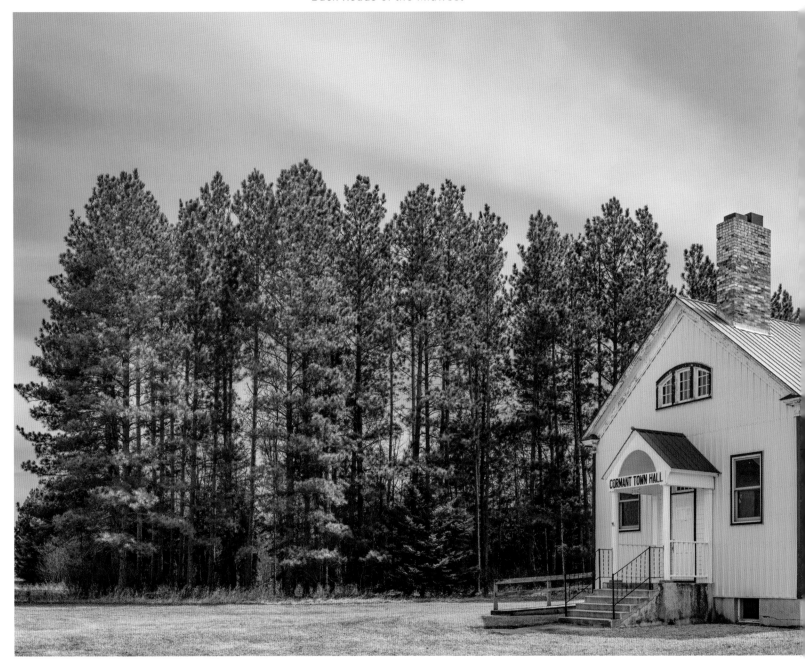

Cormant Town Hall, Minnesota

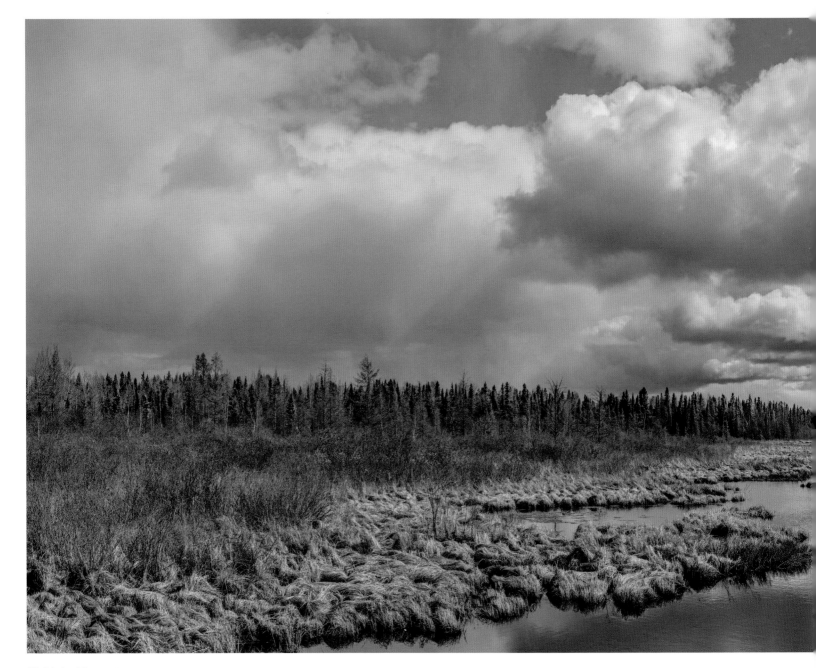

Wolf Lake, Minnesota

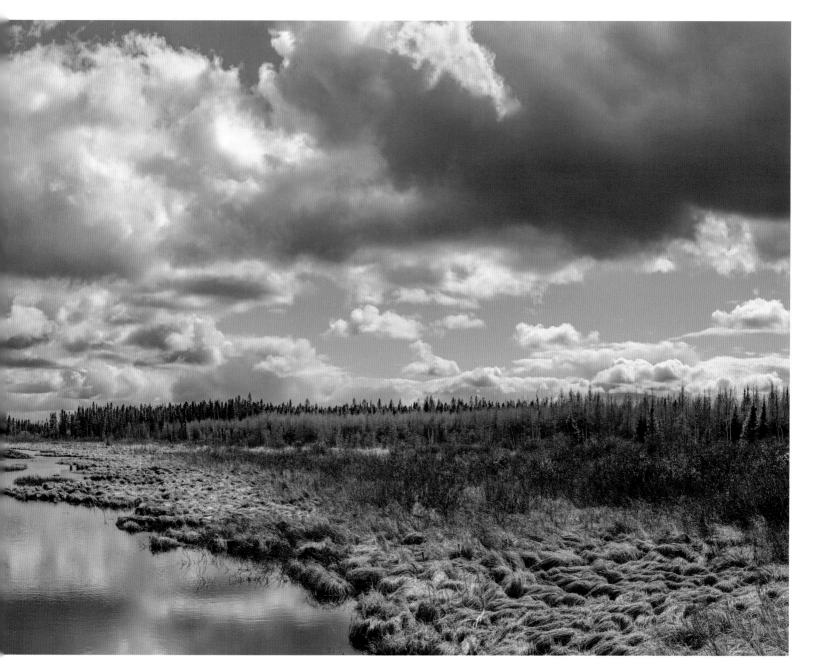

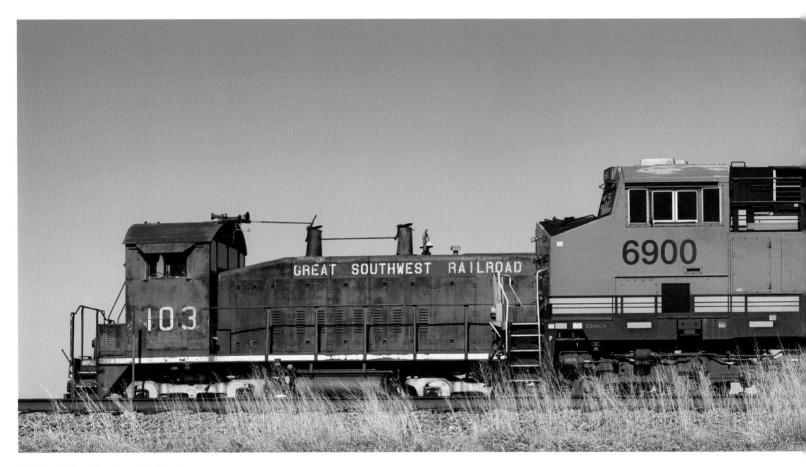

BNSF and Great Southwest Railroad

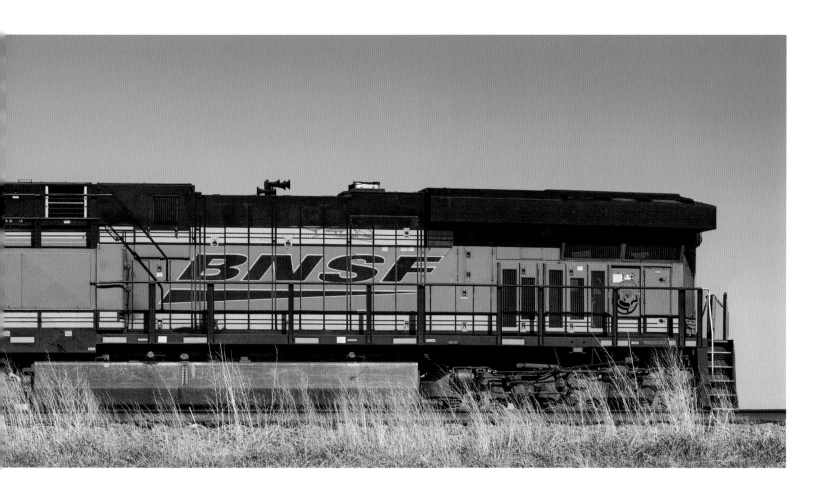

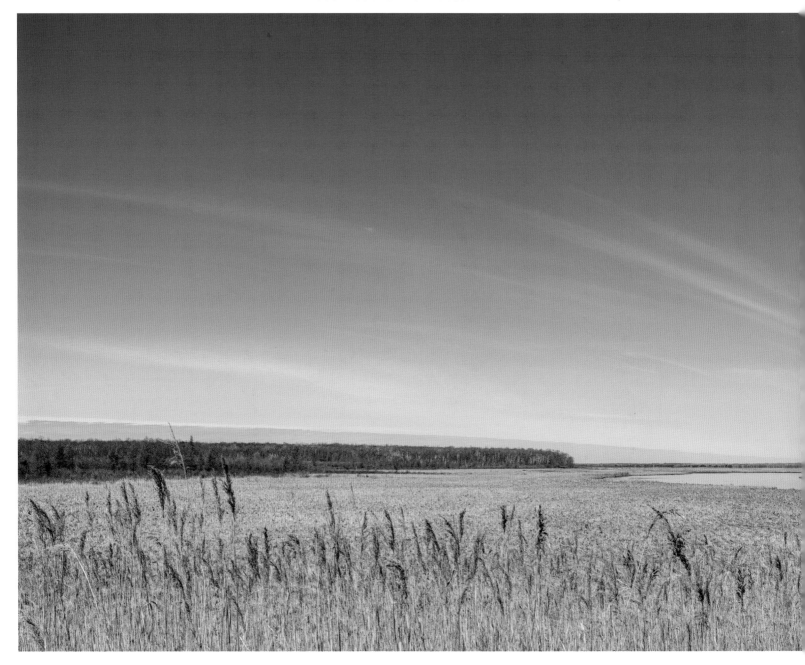

Boy River, Minnesota

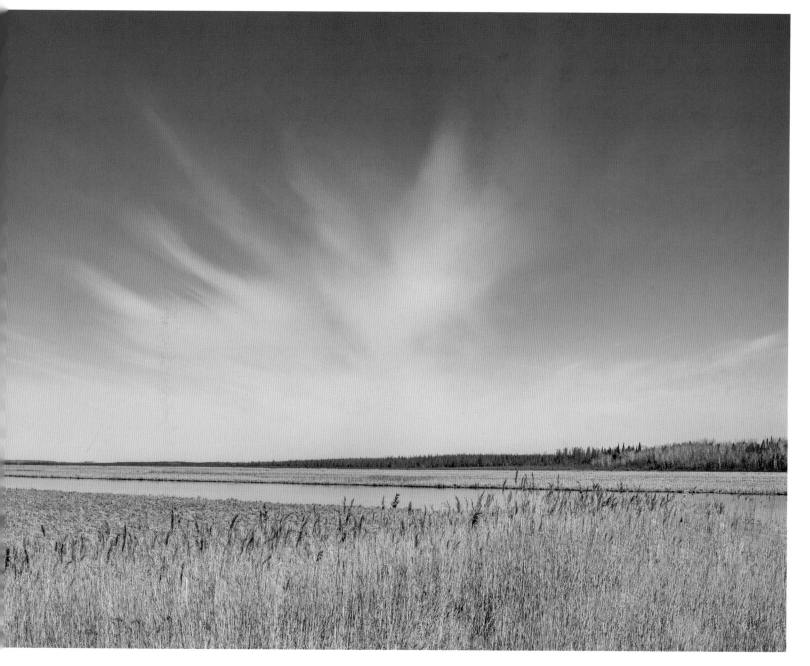

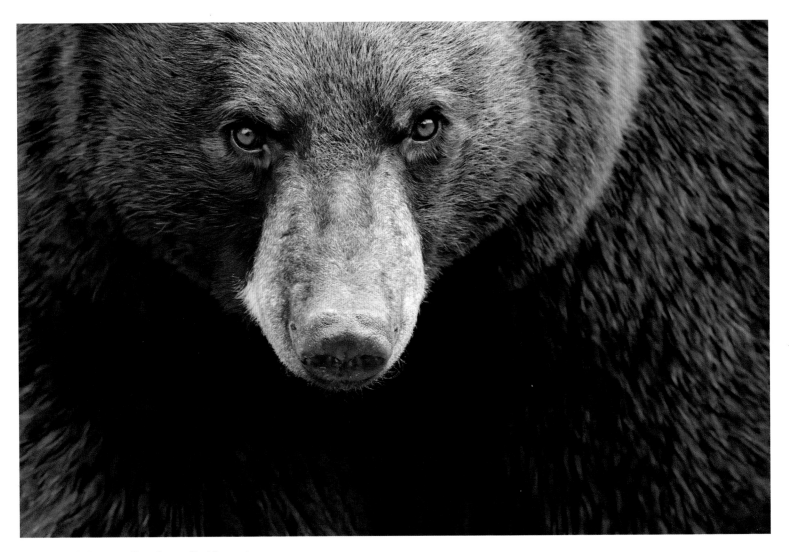

"Tasha," North American Bear Center, Ely, Minnesota

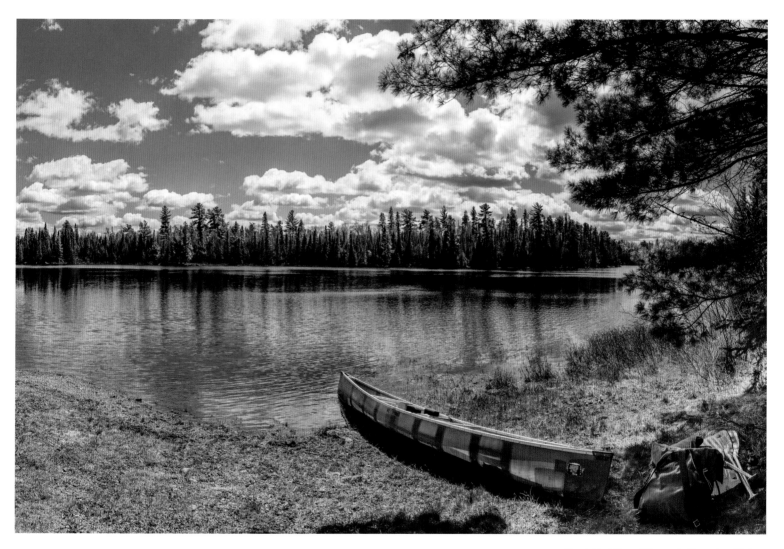

Kawishiwi River, Minnesota Boundary Waters

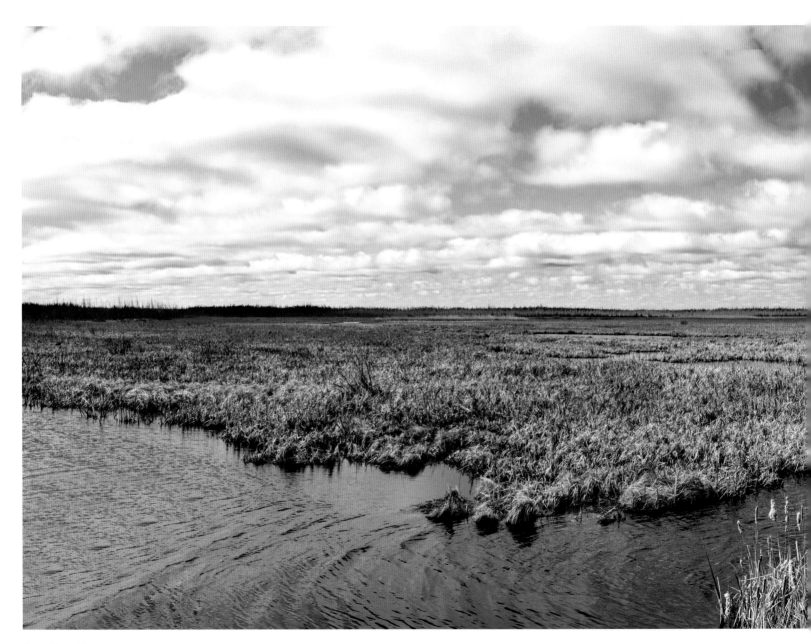

Swan River, Minnesota

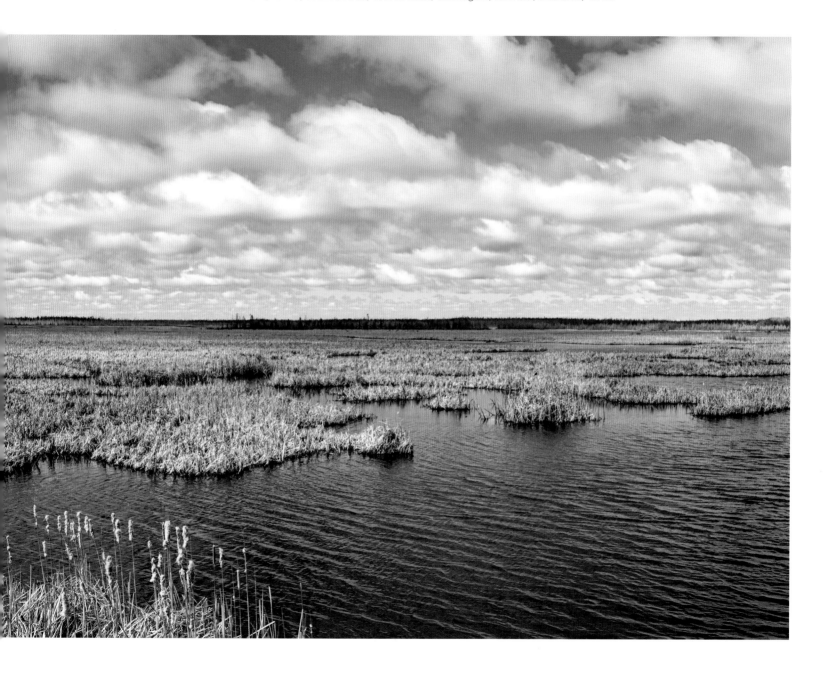

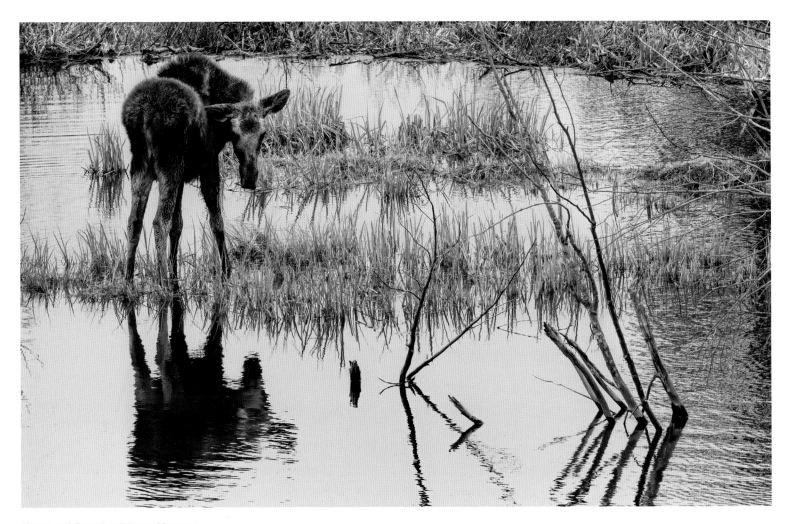

Moose calf, Boundary Waters, Minnesota

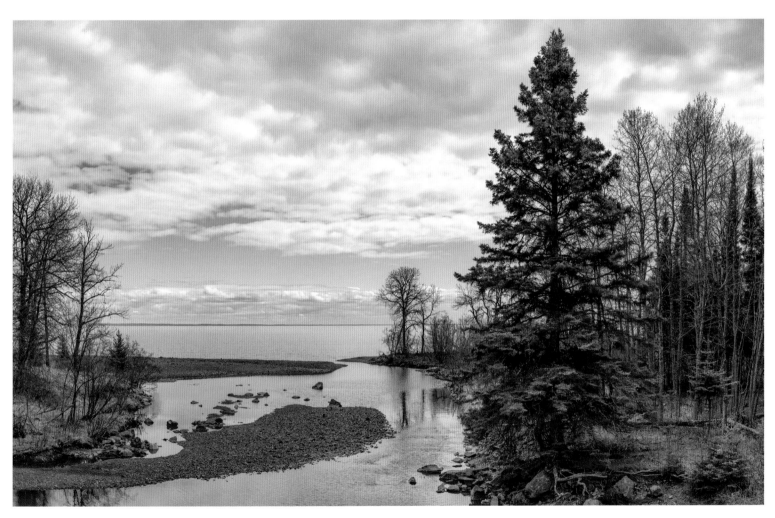

Silver Creek flowing into Lake Superior, Minnesota

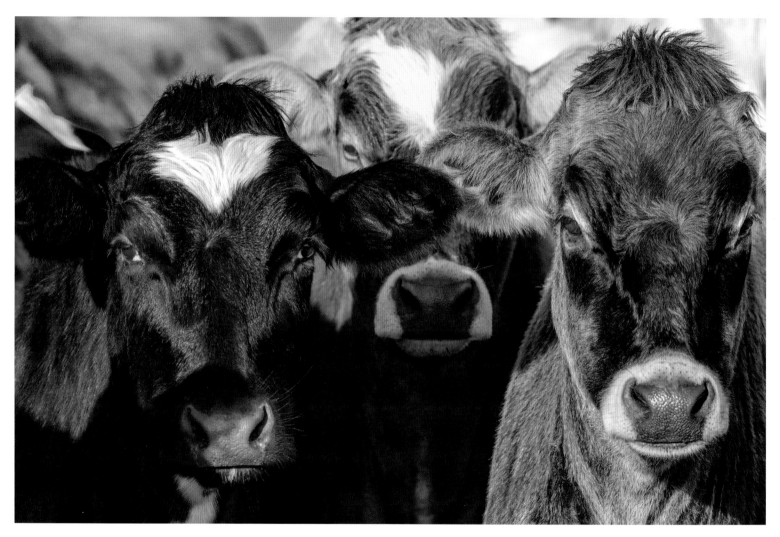

Curious Wisconsin cows

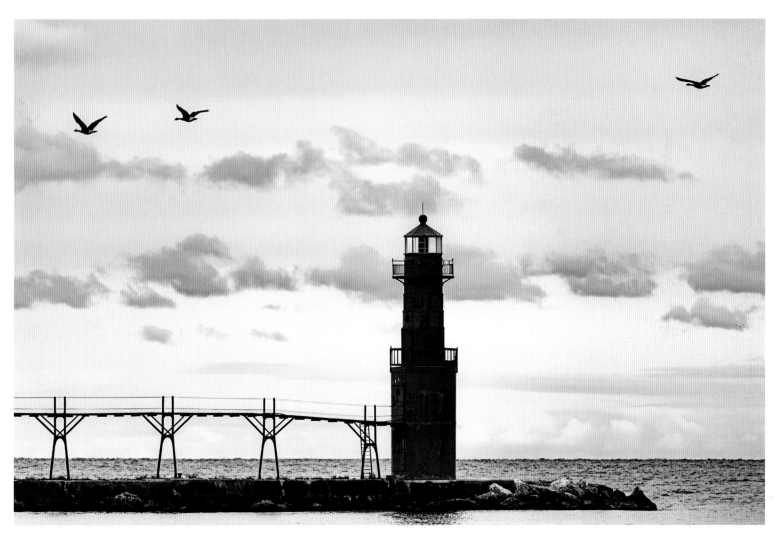

Algoma Pierhead Lighthouse, Lake Michigan, Wisconsin

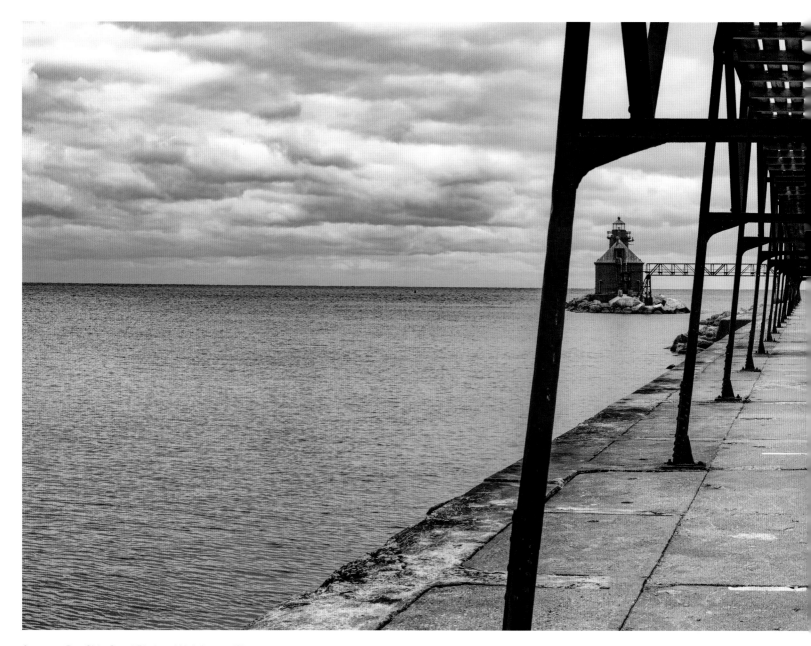

Sturgeon Bay Ship Canal Pierhead Lighthouse, Wisconsin

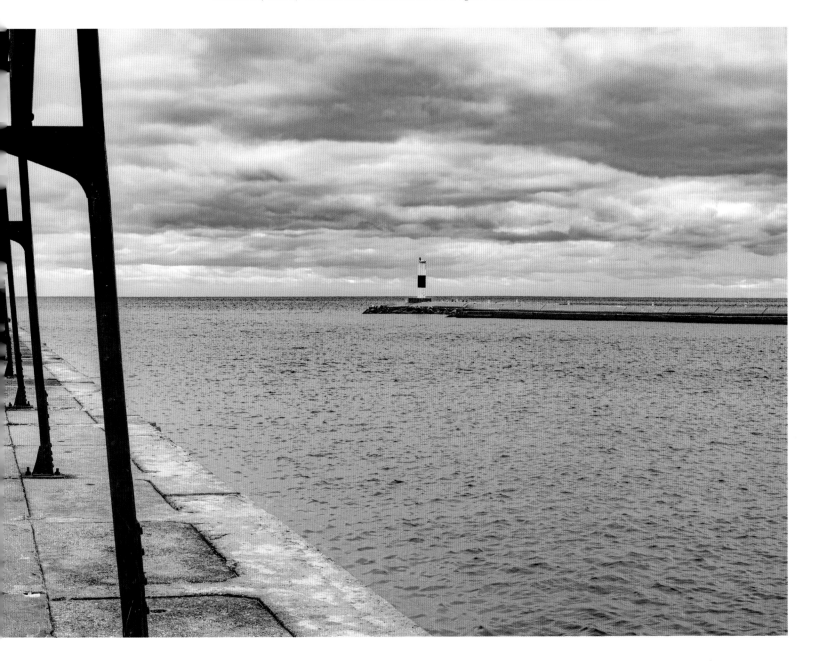

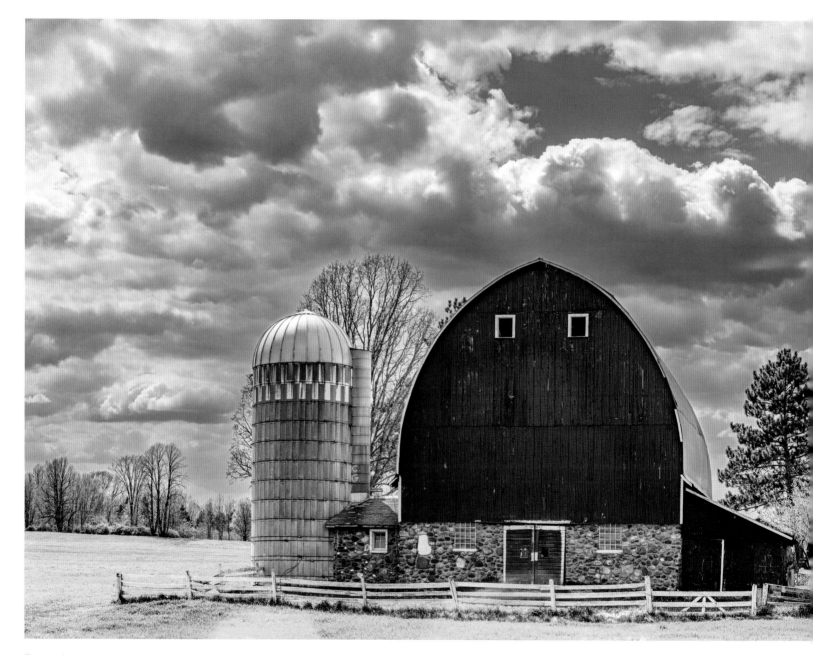

Barn and spring trees, Ladysmith, Wisconsin

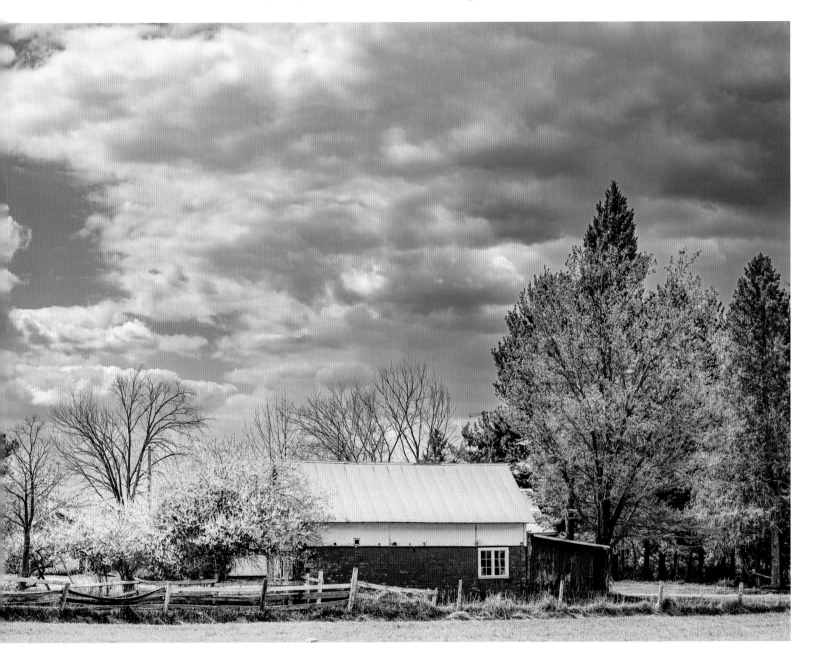

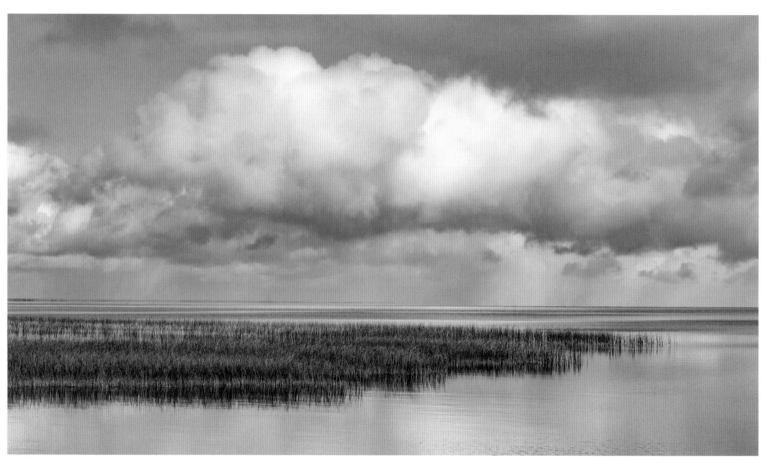

Red Lake, Wisconsin

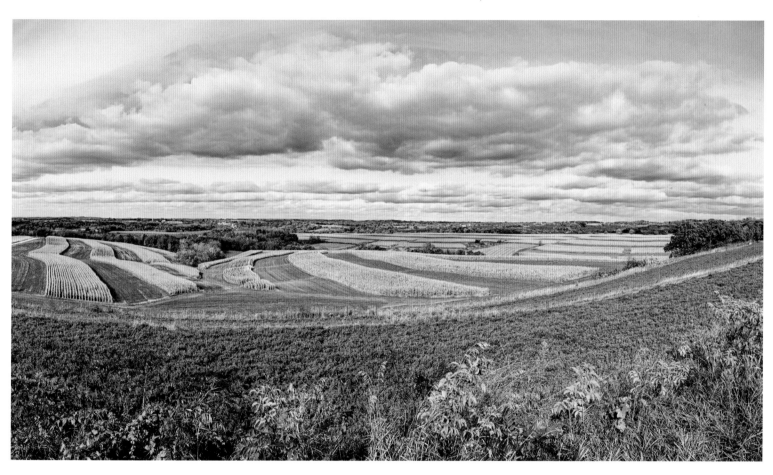

View from County Road E, Wisconsin

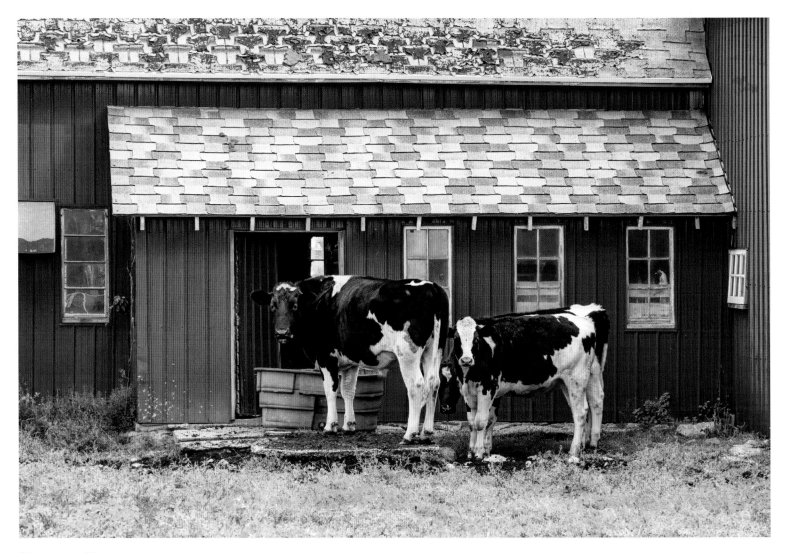

Friendly cows, Wisconsin
Photobombed by a chicken! I didn't see him until I processed the photo.

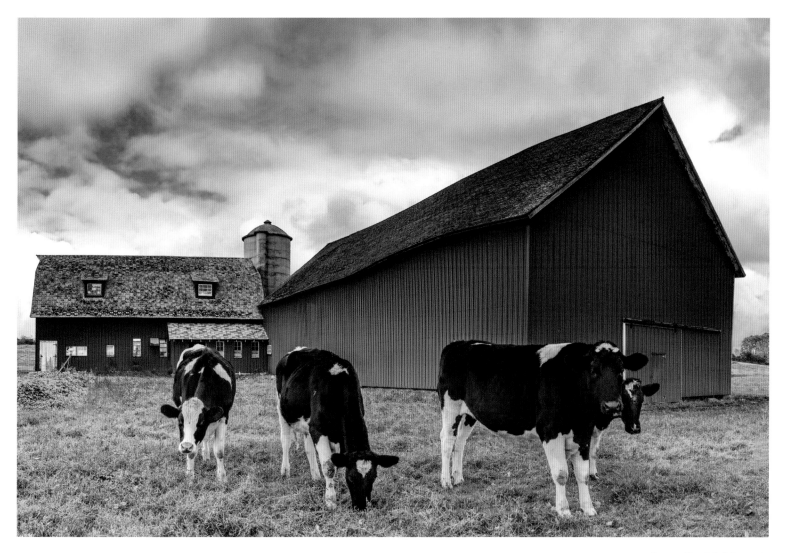

County Road C, Wisconsin
The cows came over to say hello.

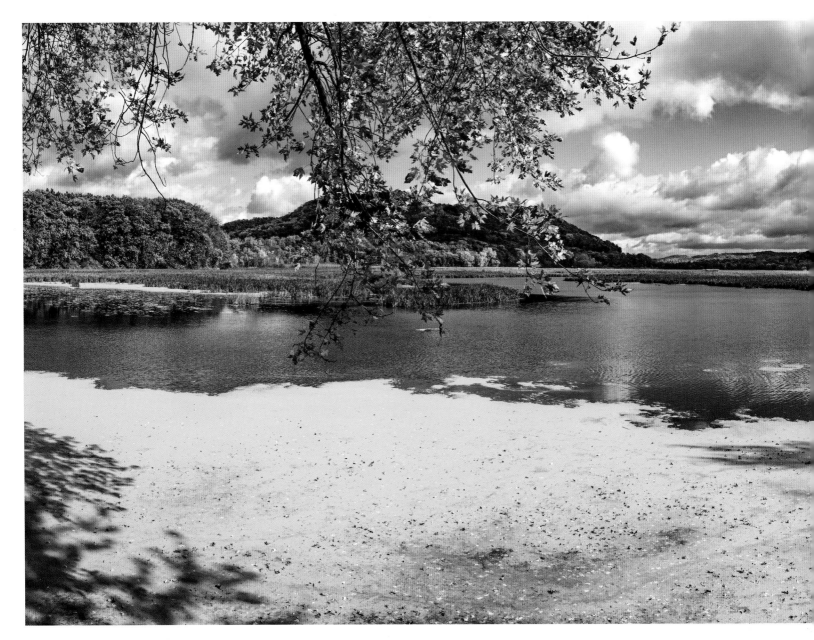

Rieck's Lake, Wisconsin

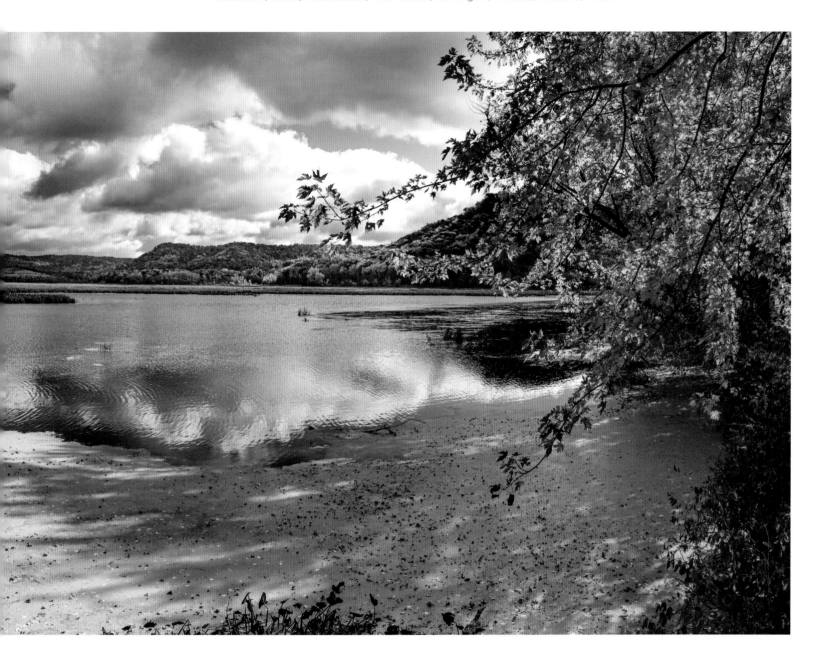

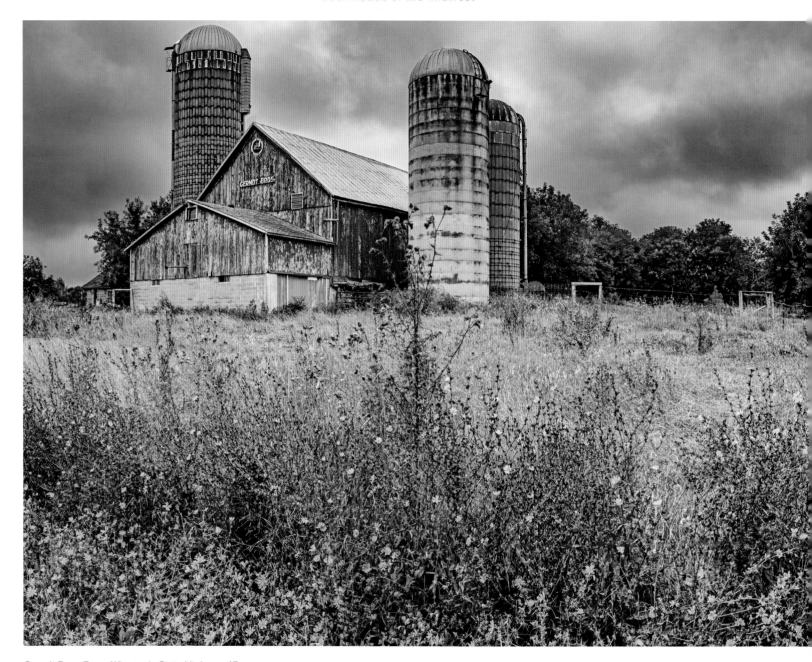

Gerndt Bros. Farm, Wisconsin State Highway 45

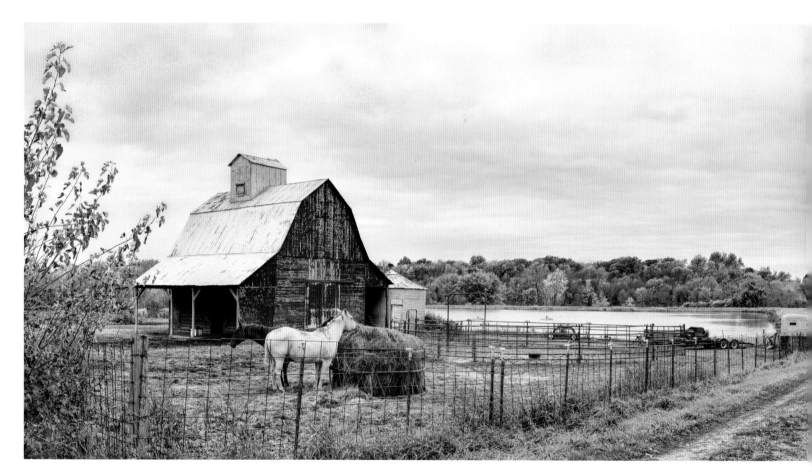

Farm at the end of a dirt road, Wisconsin

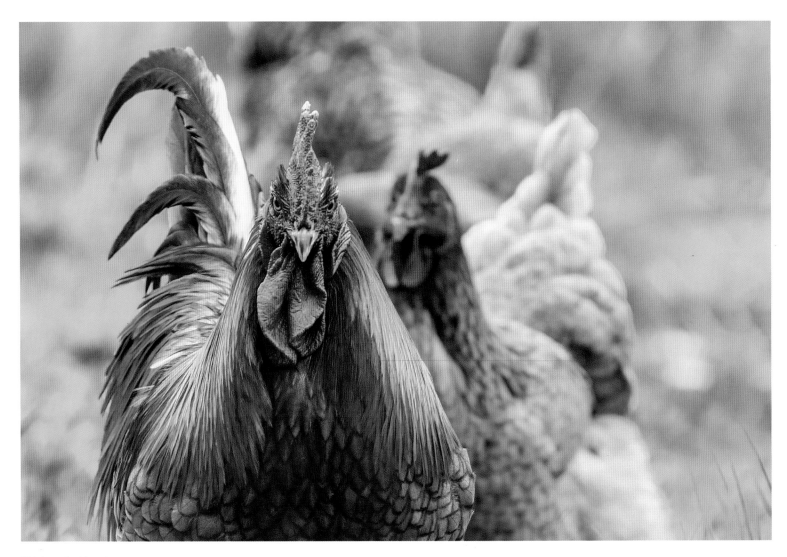

Chickens looking dangerous

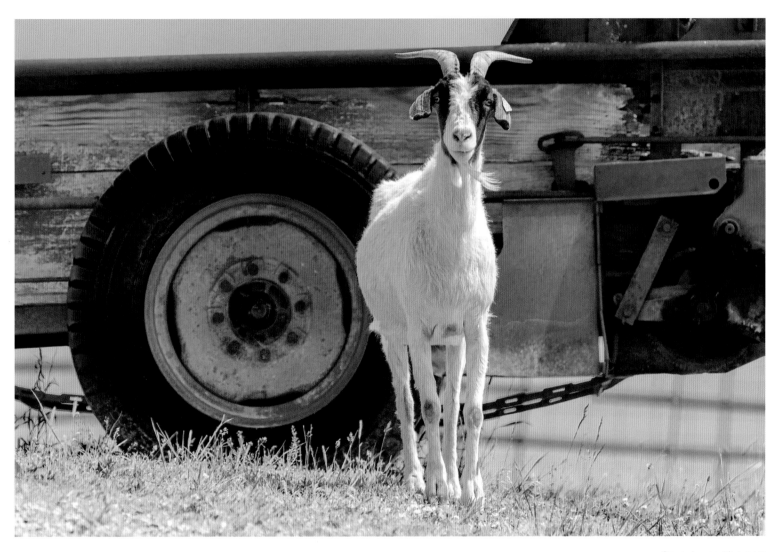

Stare-down with a goat

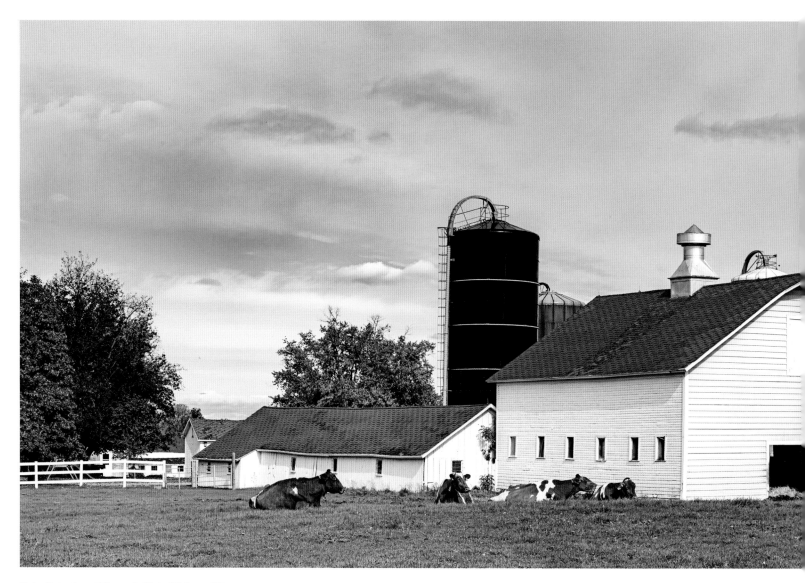

Dairy farm along Wisconsin State Highway 89

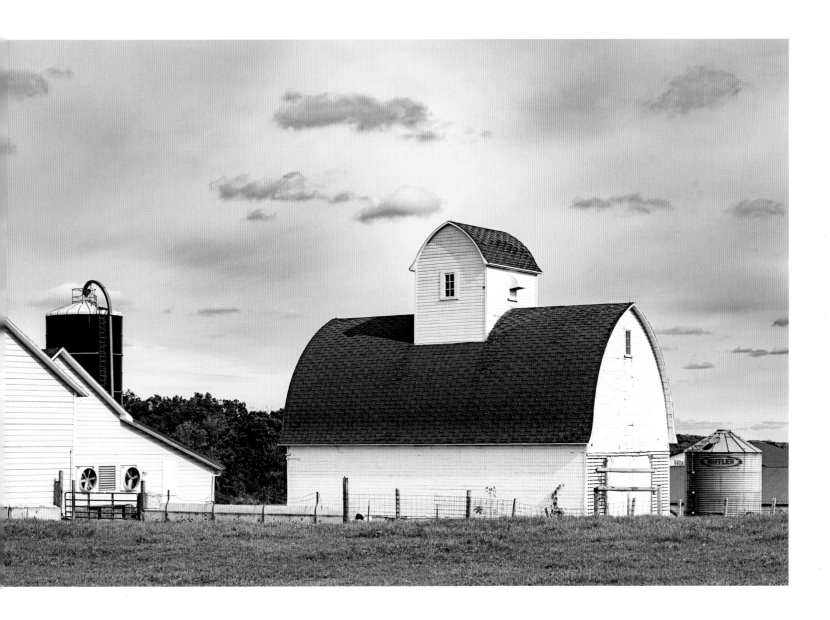

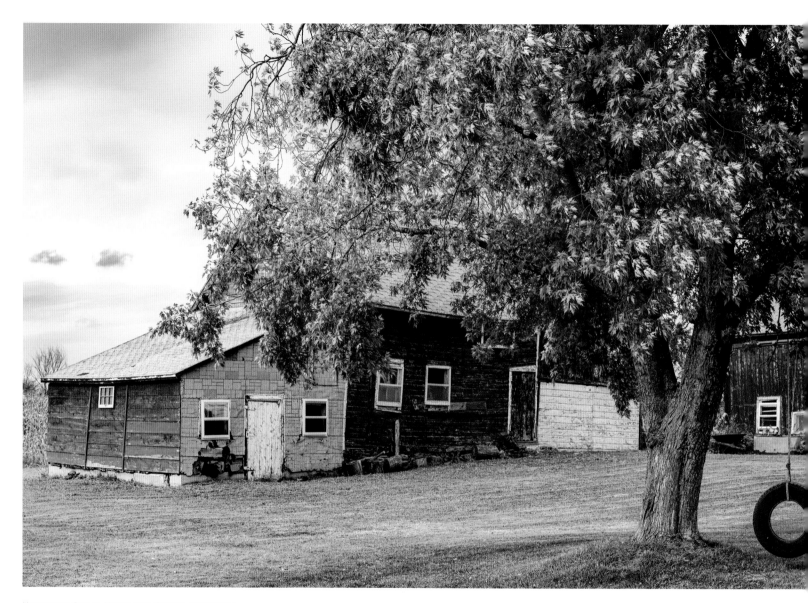

Kewaunee Street, Kewaunee County, Wisconsin

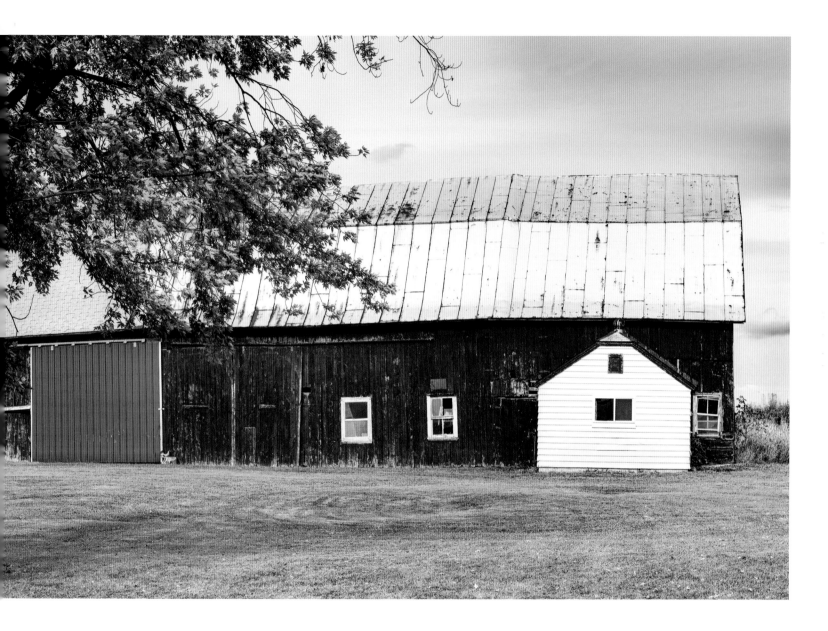

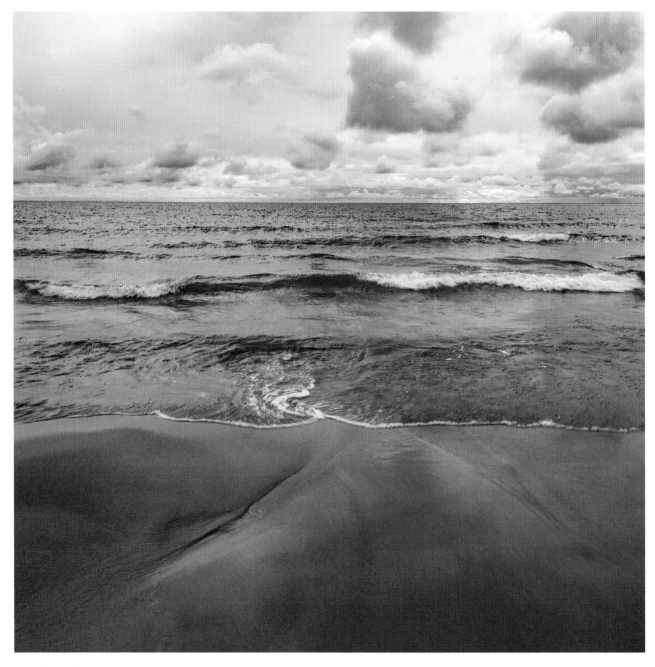

Lake Huron, Michigan

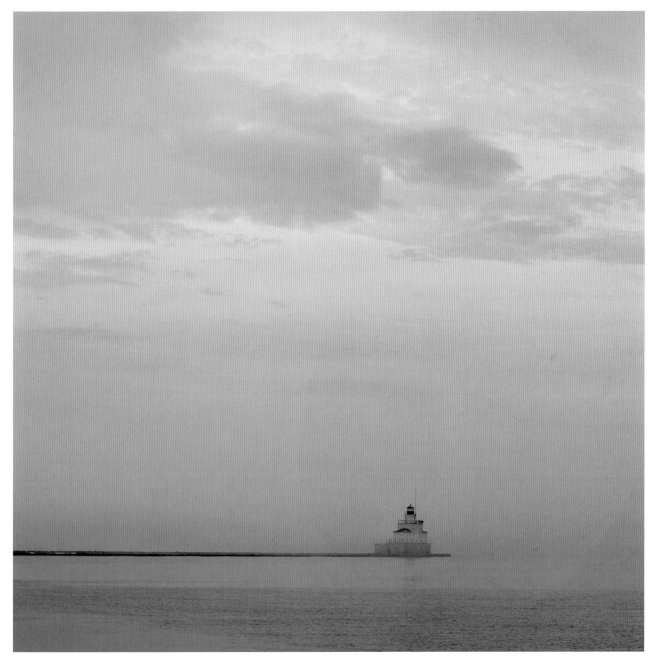

Manitowoc Lighthouse, Lake Michigan

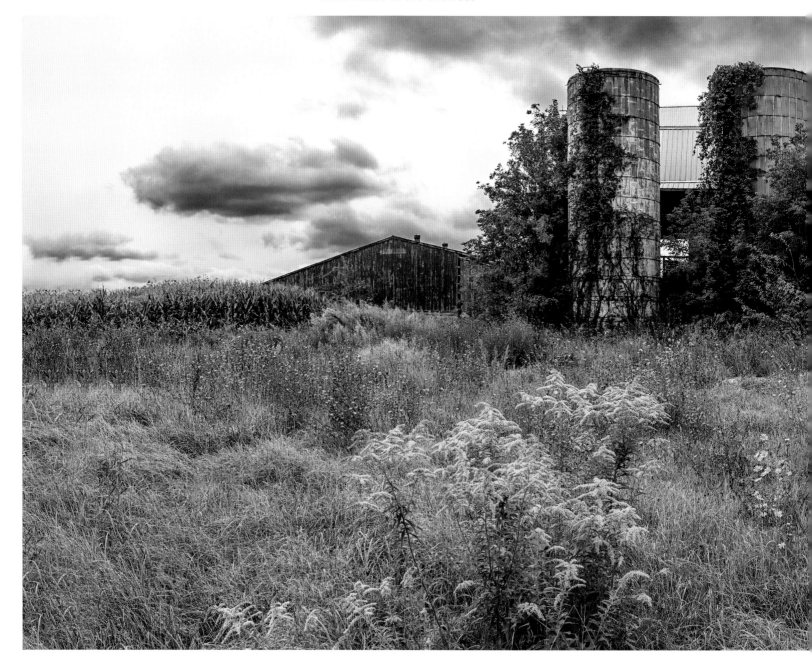

Fowler Farms, Michigan

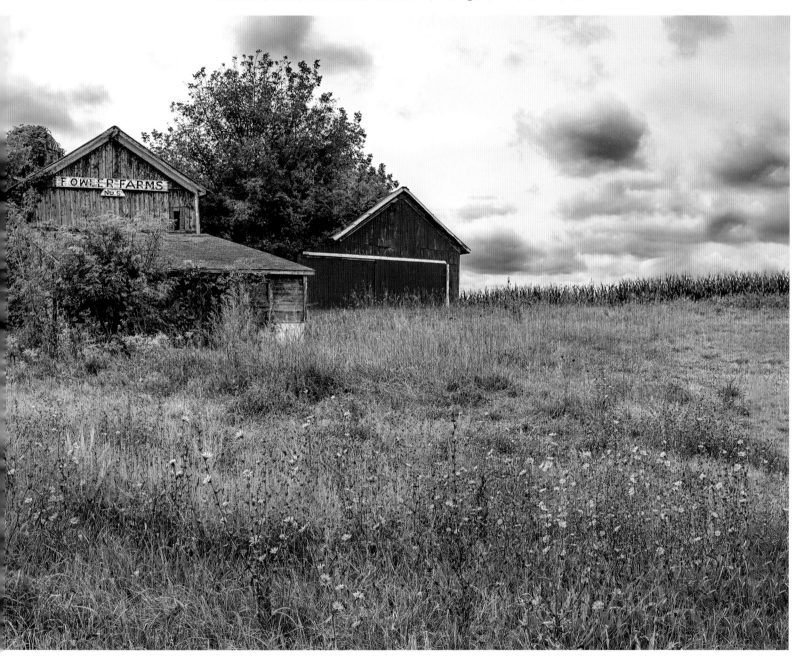

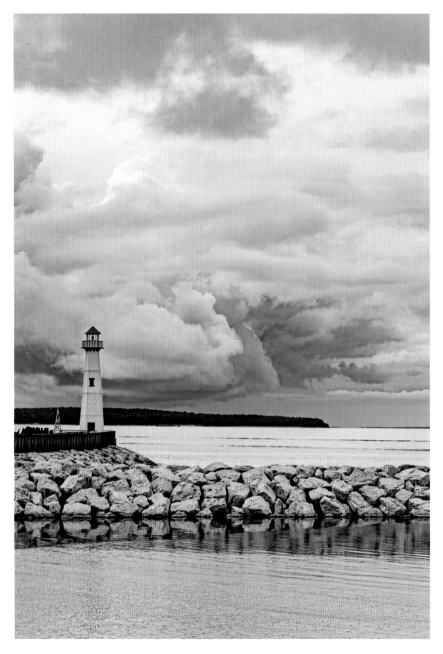

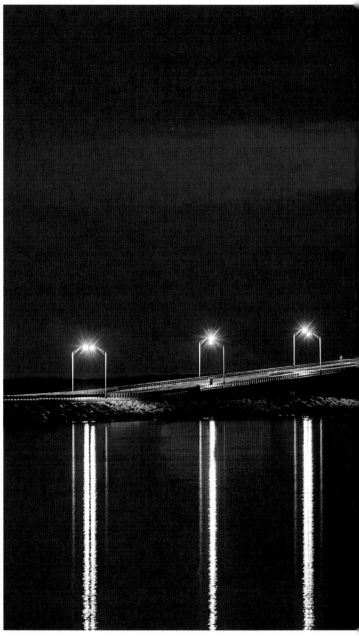

Saint Ignace Light, Lake Huron, Upper Peninsula, Michigan

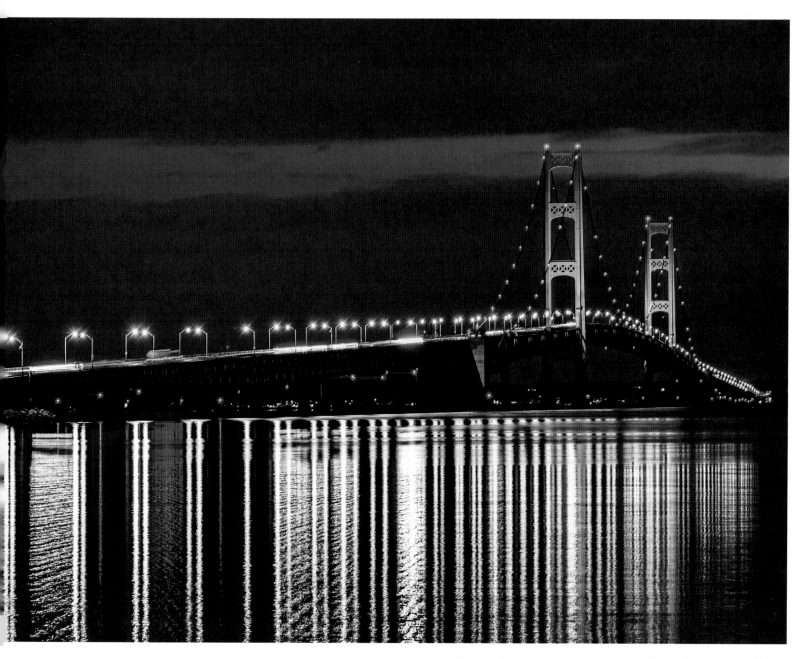

Mackinac Bridge, connecting the Upper and Lower Peninsulas of Michigan

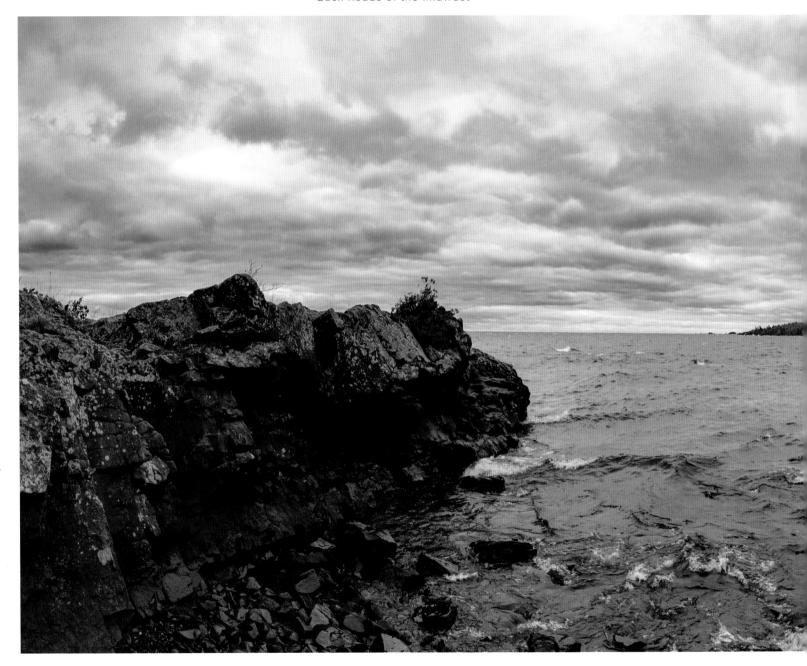

Eagle Harbor Lighthouse on the Keweenaw Peninsula, Eagle Harbor, Michigan

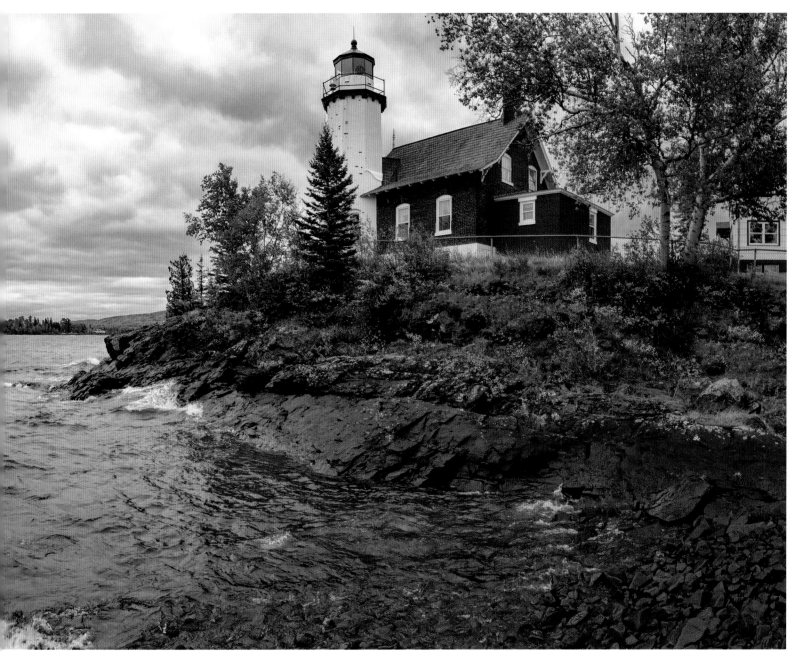

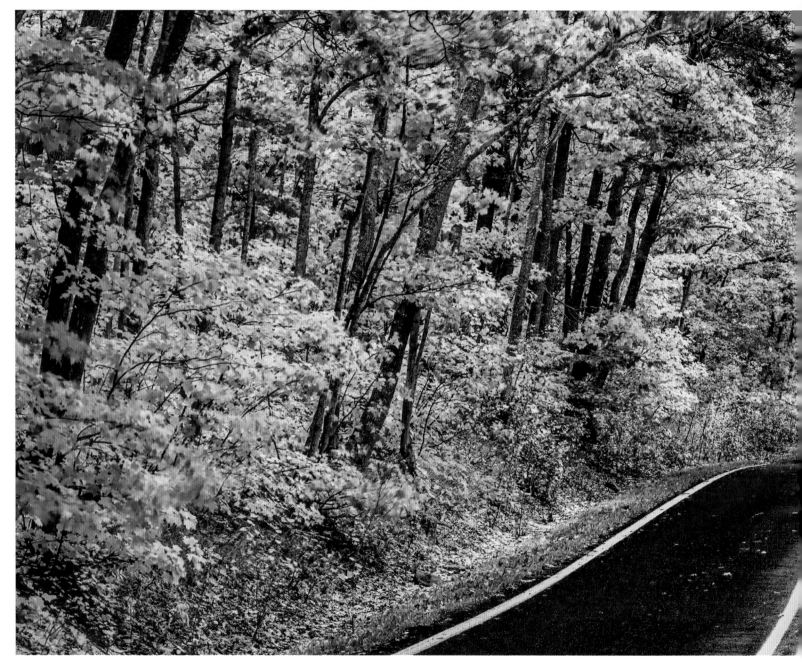

Fall colors, Michigan State Highway 41

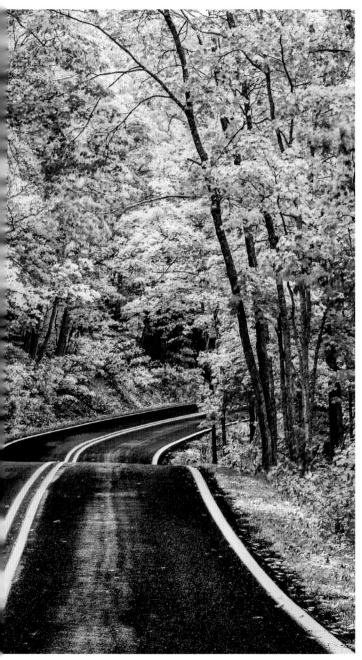

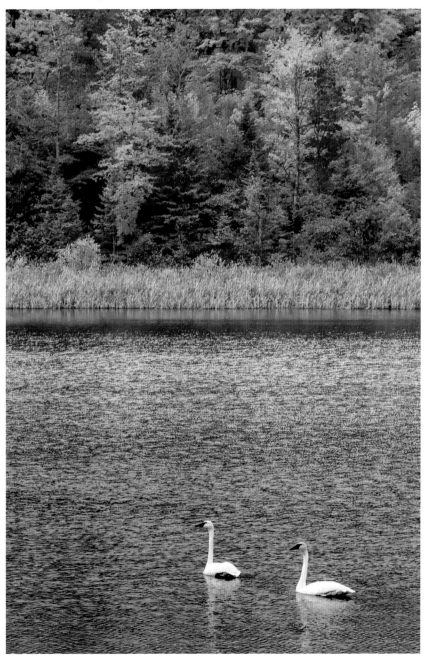

Trumpeter swans, Michigan

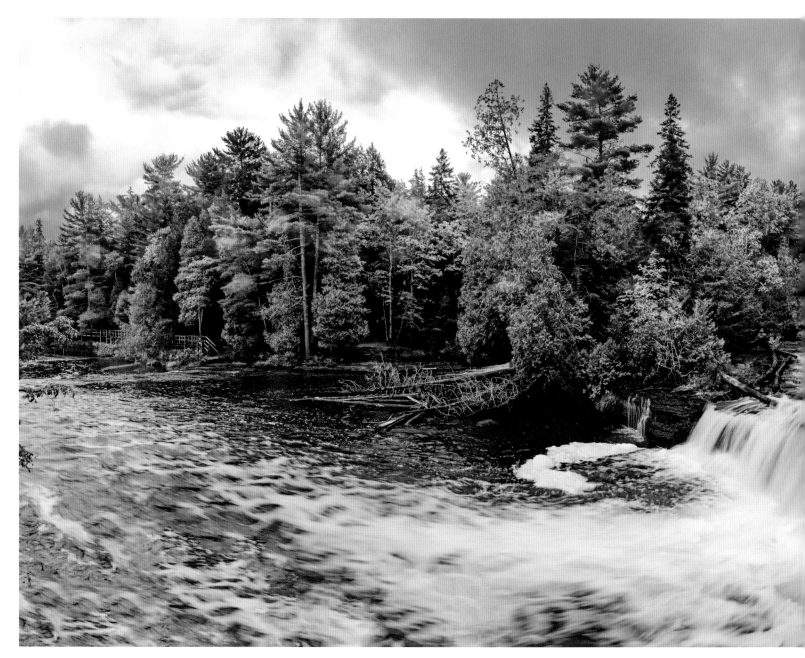

Tahquamenon Falls, Upper Peninsula, Michigan

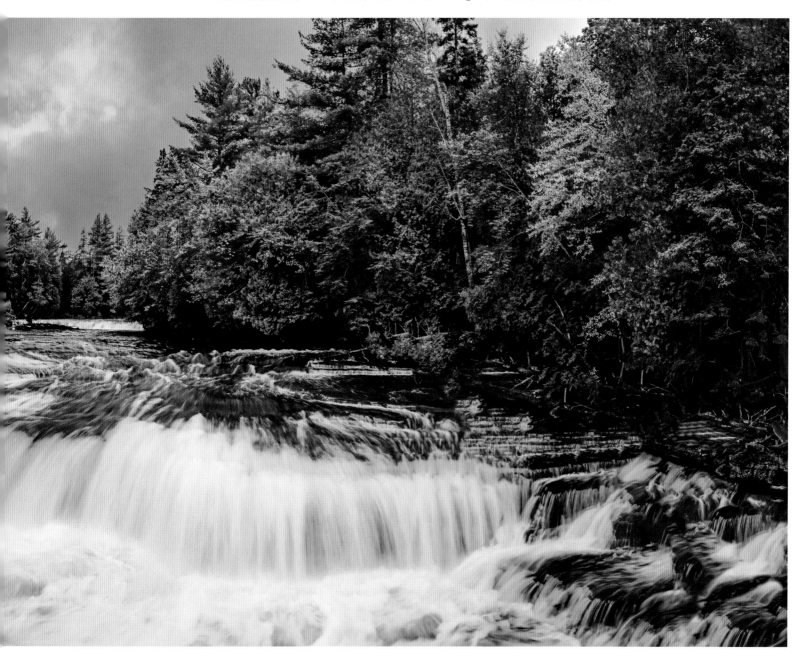

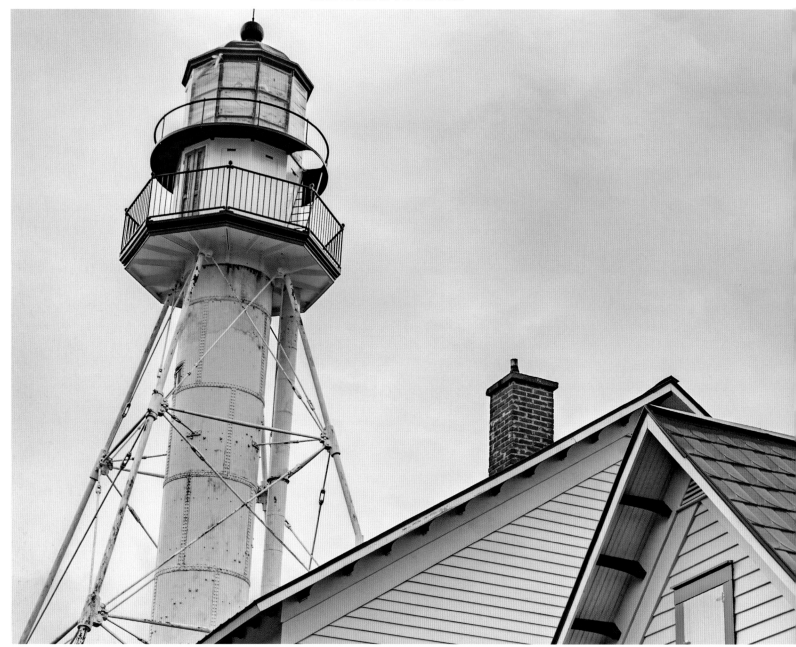

Whitefish Point Light Station, Upper Peninsula, Michigan

Whitefish Bay Beach, Lake Superior, Upper Peninsula, Michigan

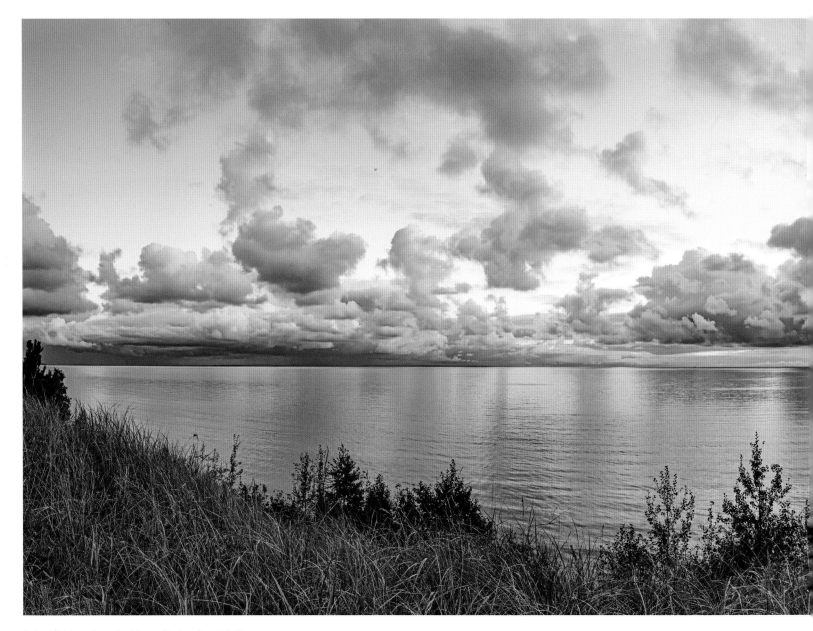

Lake Michigan from the Upper Peninsula of Michigan

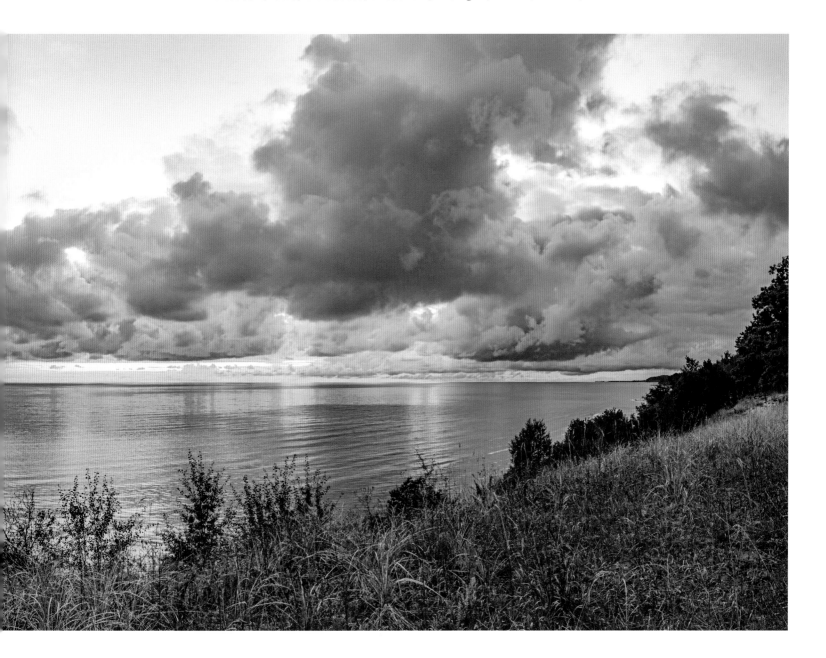

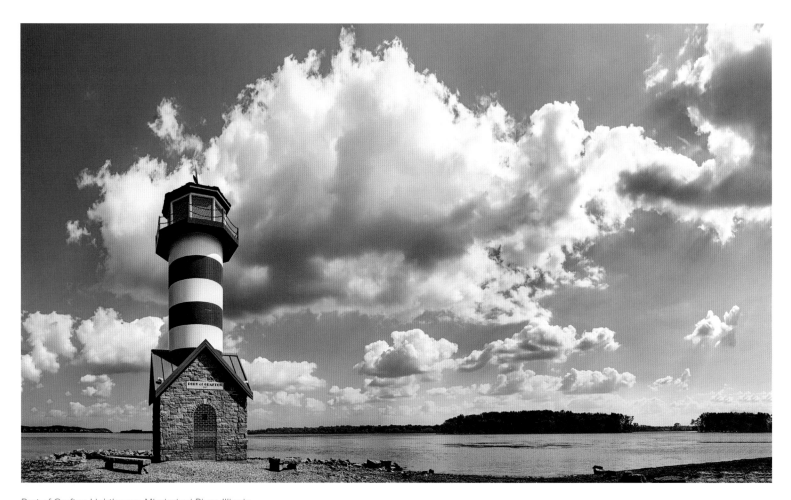

Port of Grafton Lighthouse, Mississippi River, Illinois

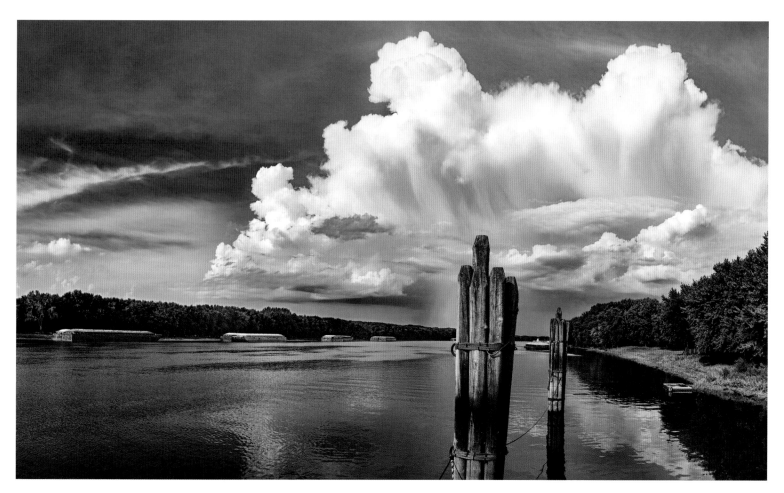

Illinois River from Illinois Valley Veterans Memorial Bridge

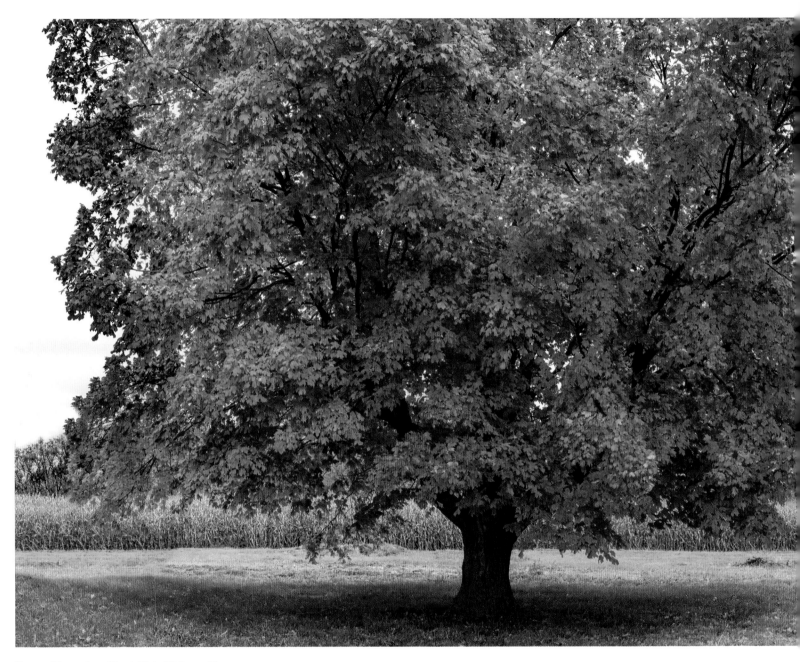

Tree and barn along Illinois State Highway 92

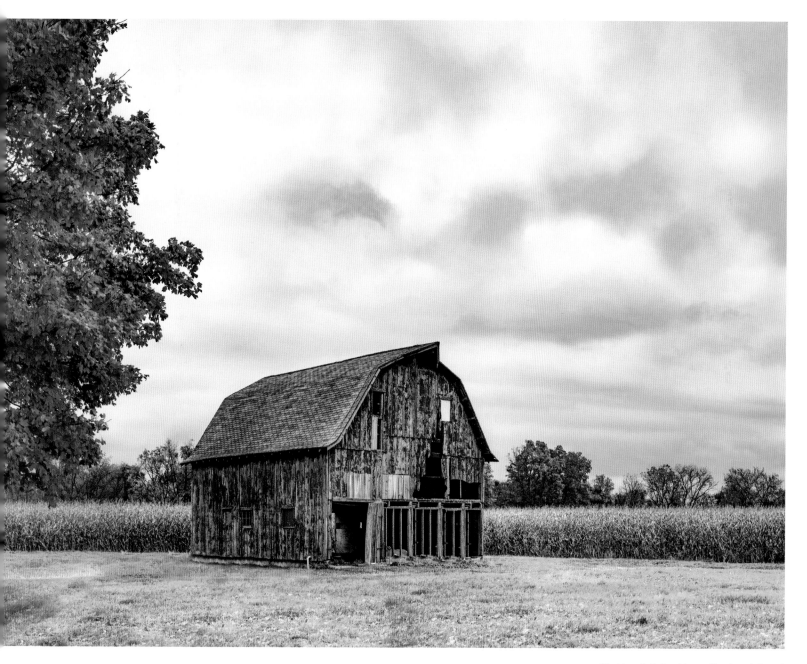

That is a full-sized barn. The tree is huge!

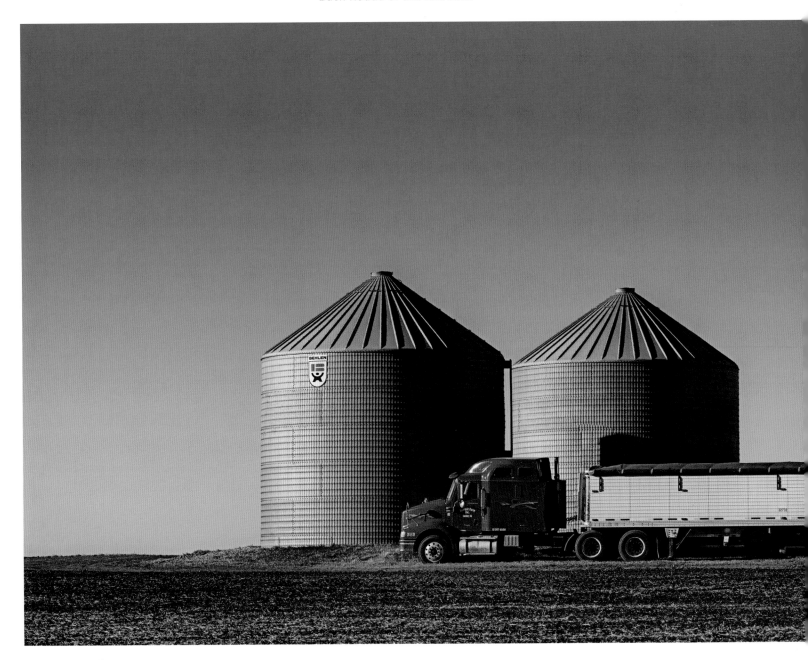

Truck and silos, Illinois

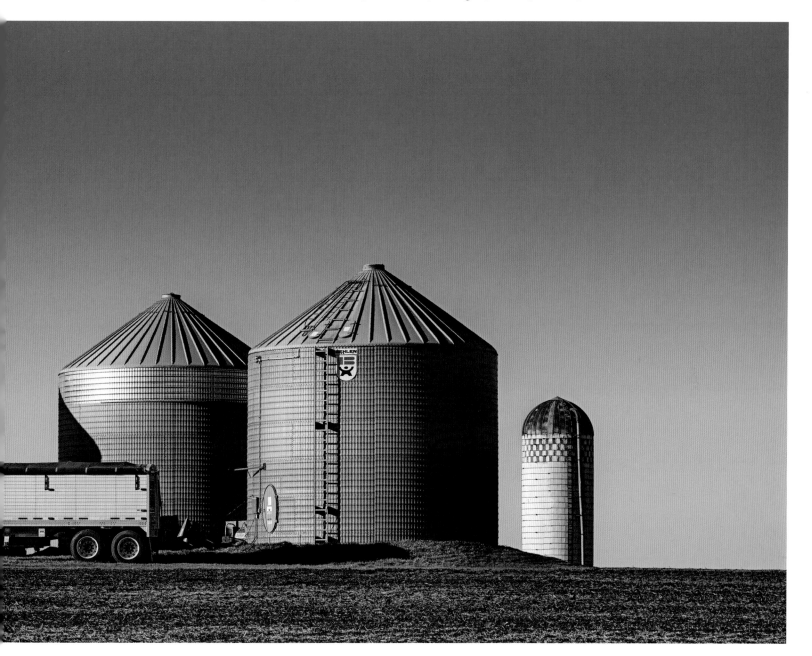

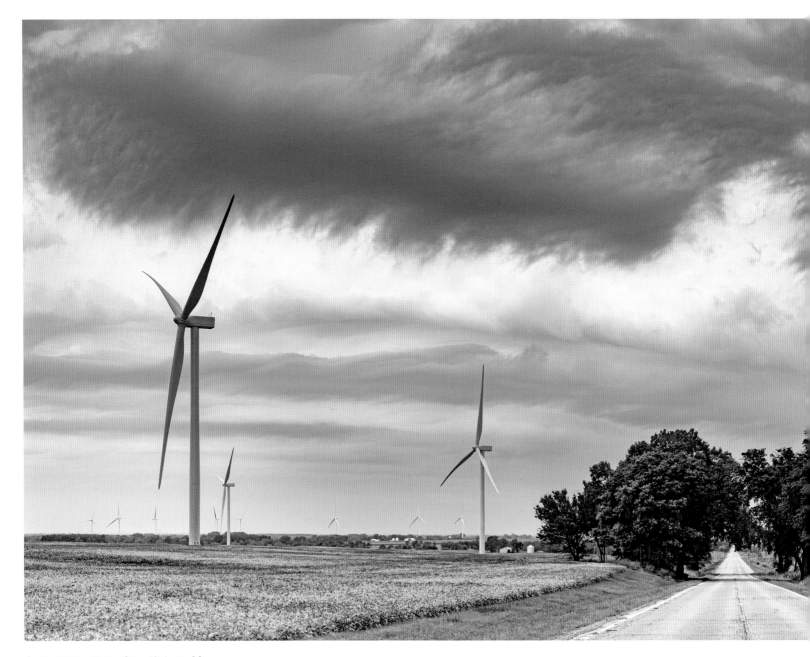

Coming storm, Illinois State Highway 26

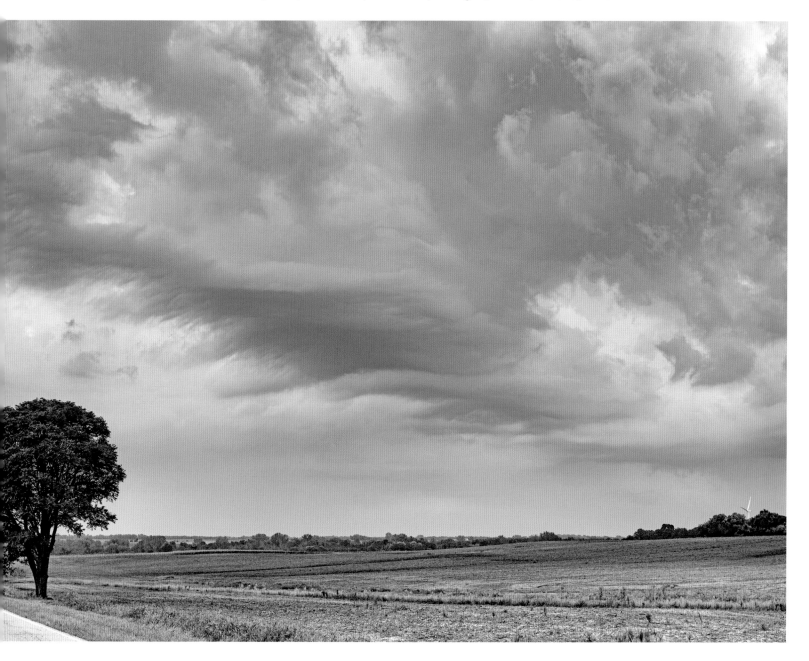

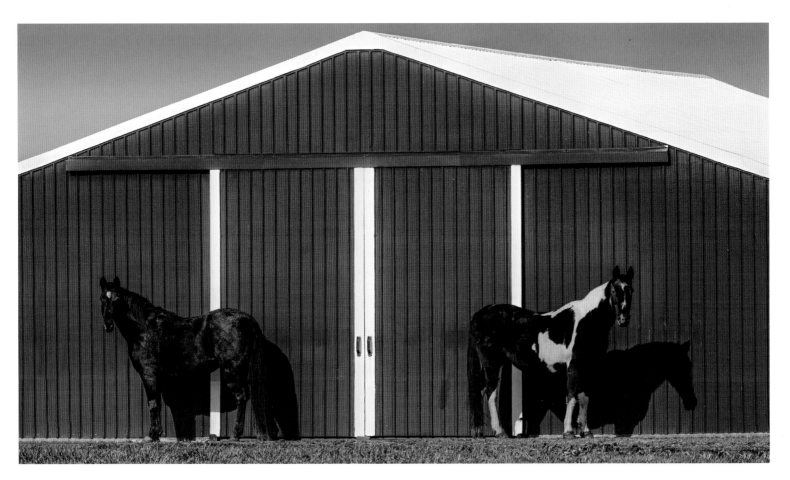

Horses, Illinois
Yes, they were just like that. I slammed on the brakes so hard, I almost went through the windshield. I always keep a camera with a long lens right next to me in Bob.

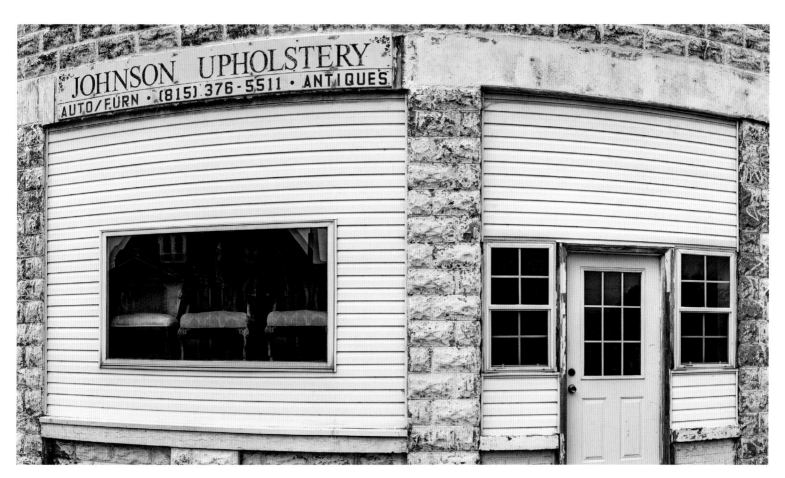

Johnson Upholstery, Ohio, Illinois

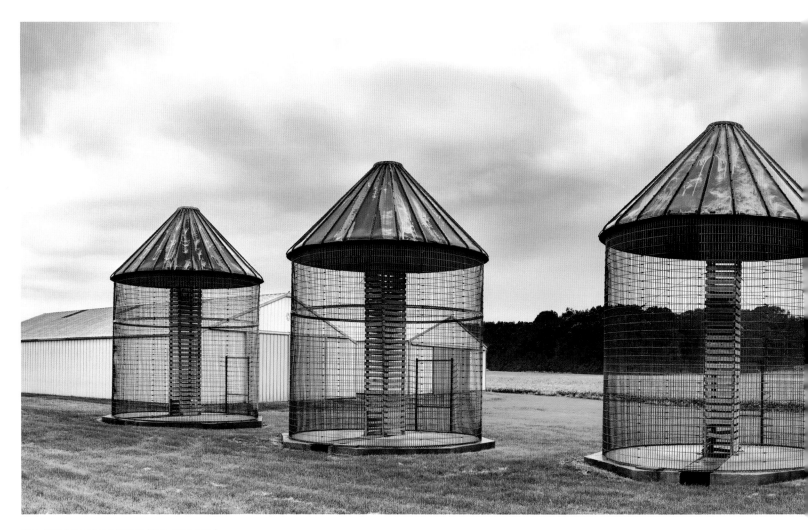

Five corn bins along Illinois State Highway 2

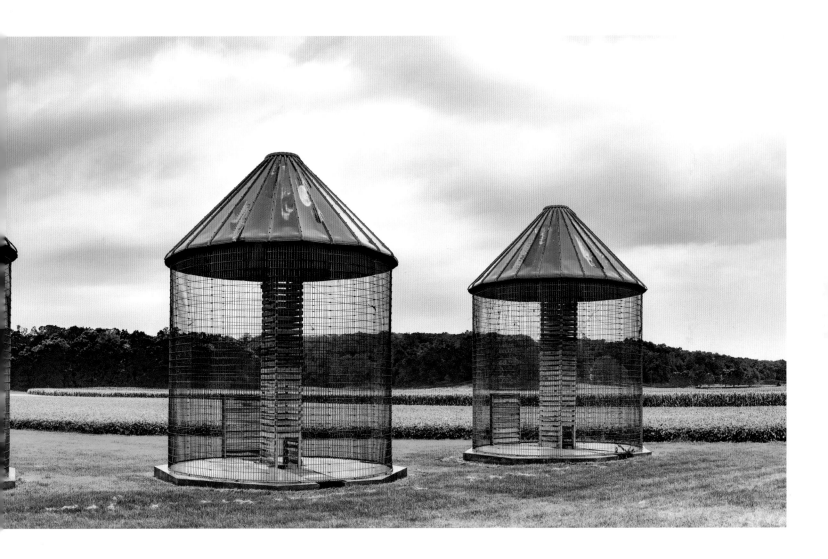

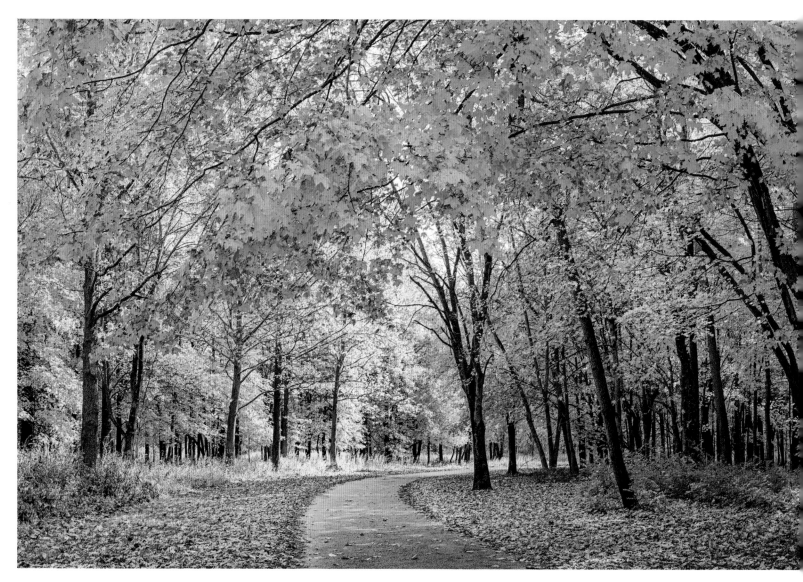

Timberdoodle Trail, Homer Lake, Illinois

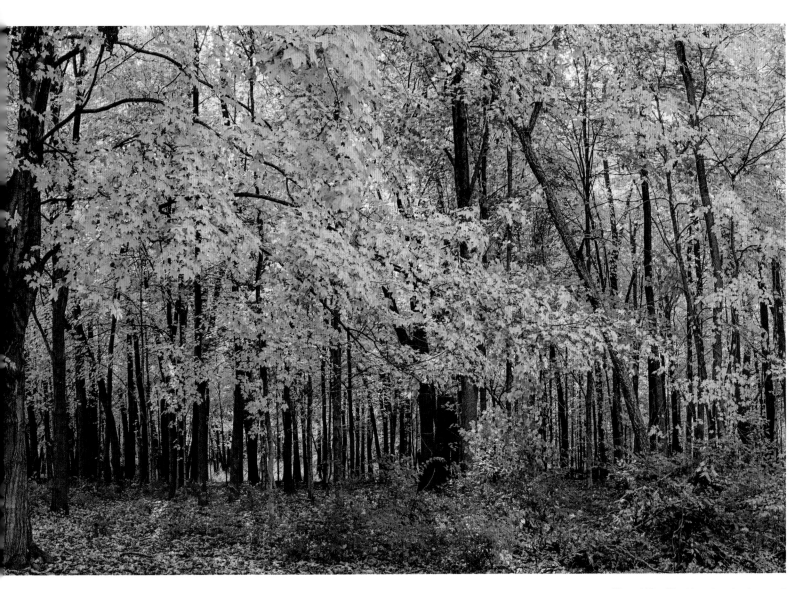

The width of that tree knocked me out!

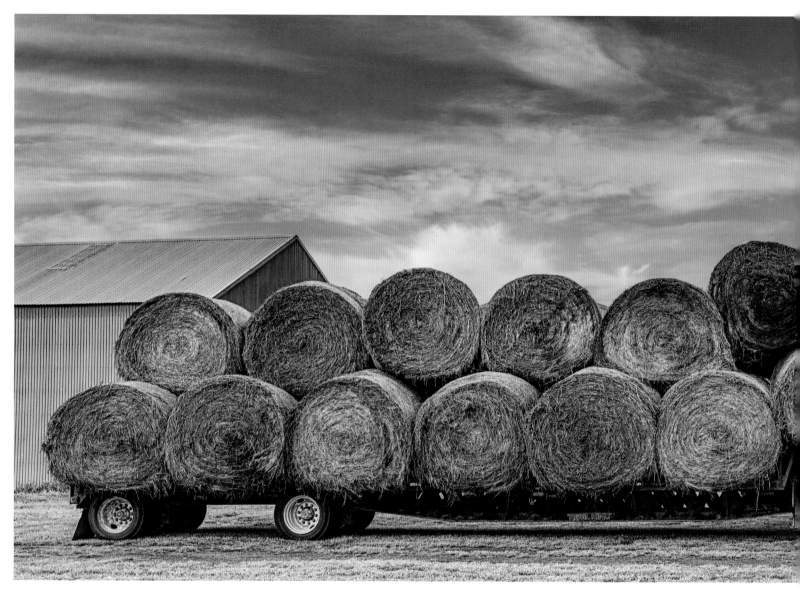

Hay truck, Illinois

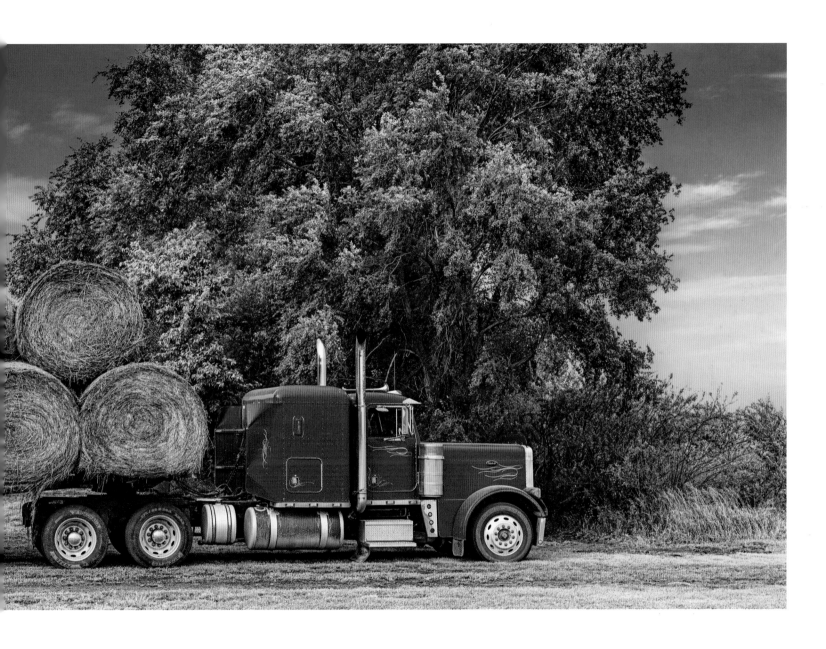

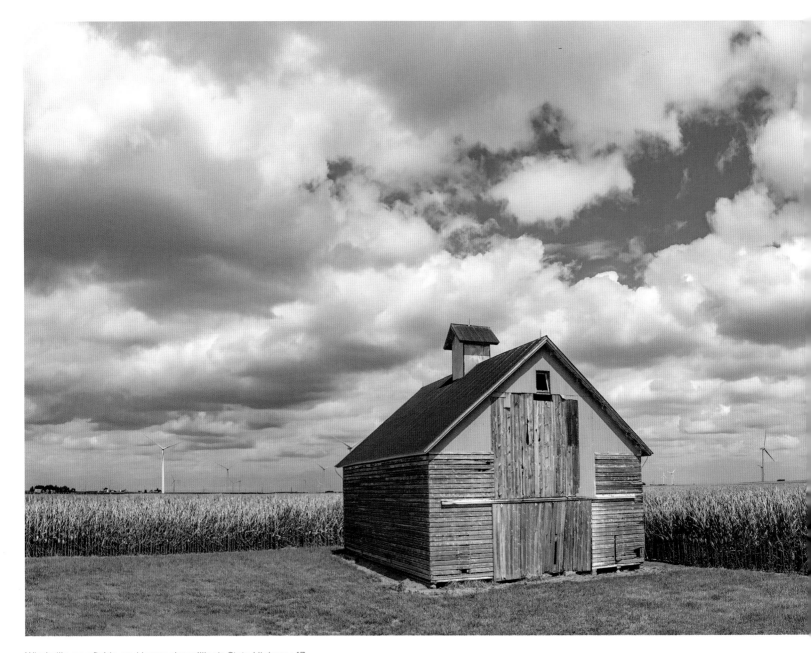

Windmills, cornfields, and barns along Illinois State Highway 47

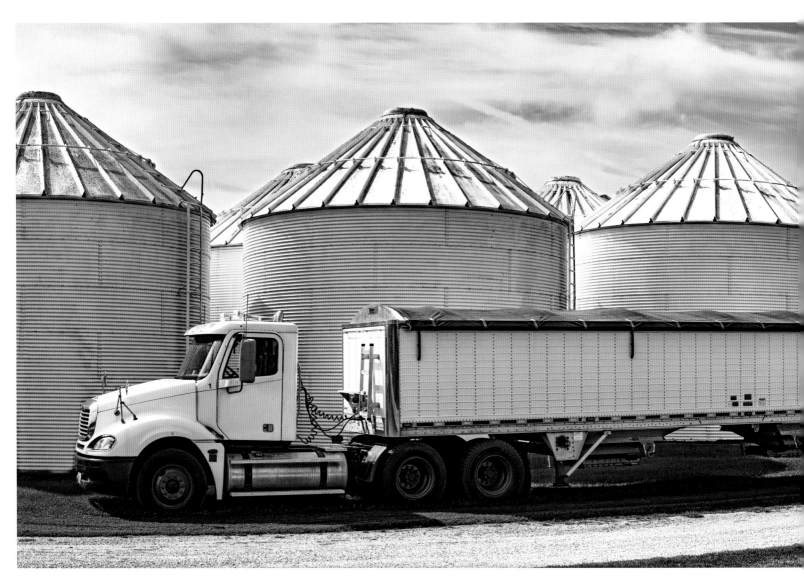

White on white, Lexington, Illinois

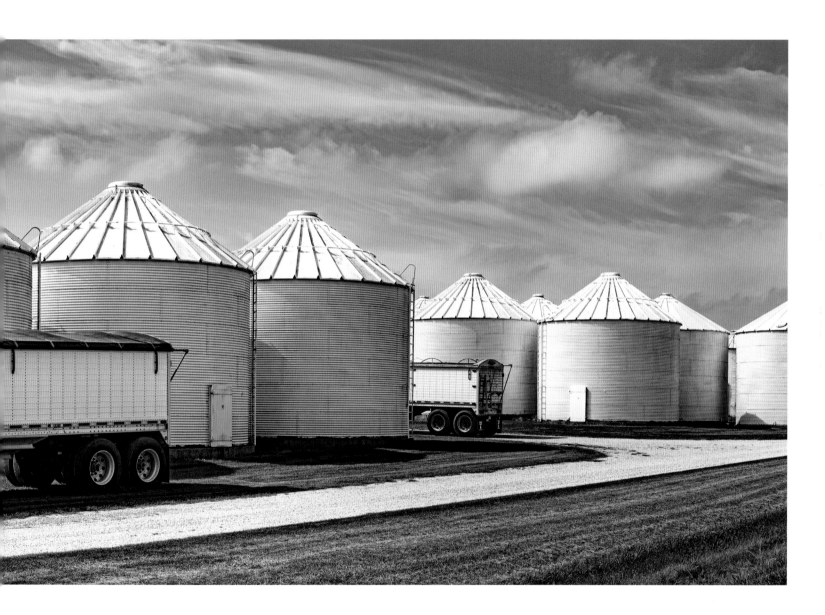

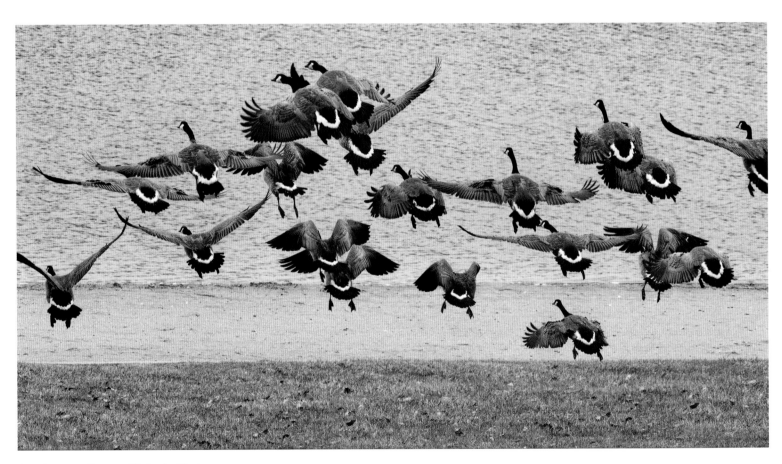

Canada geese, Emiquon Wetlands, Illinois

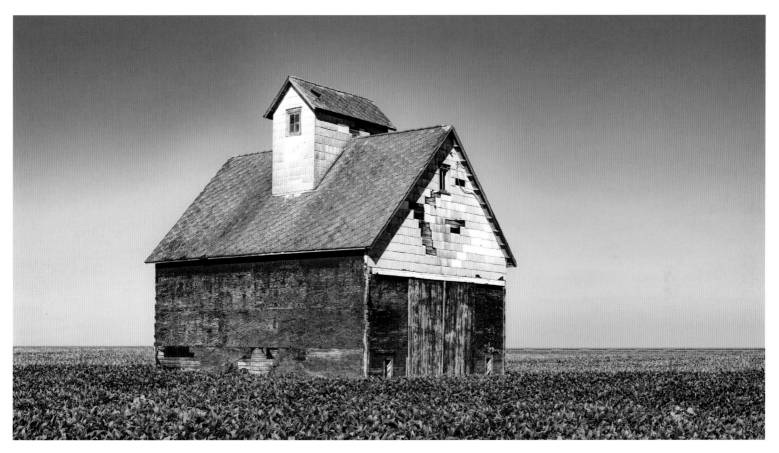

Old schoolhouse on County Road 6, Illinois

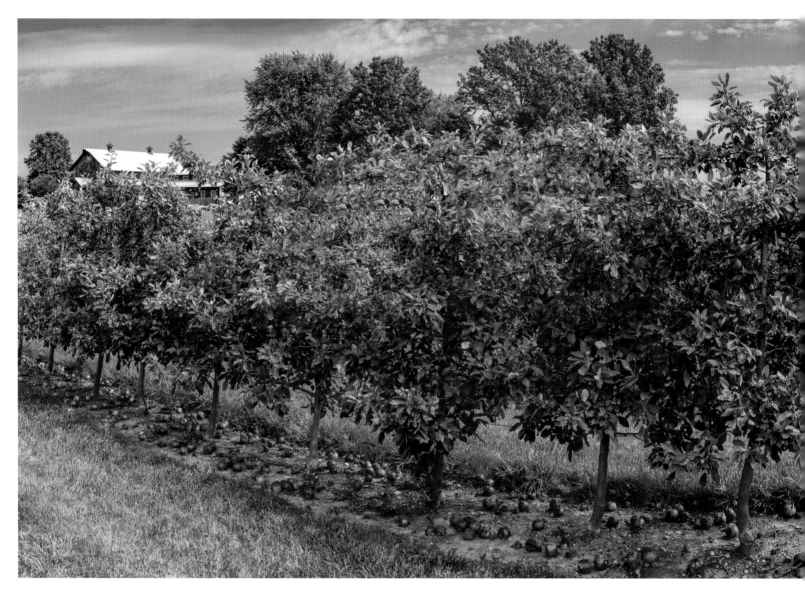

Kuipers Family Farm apple orchard, Illinois

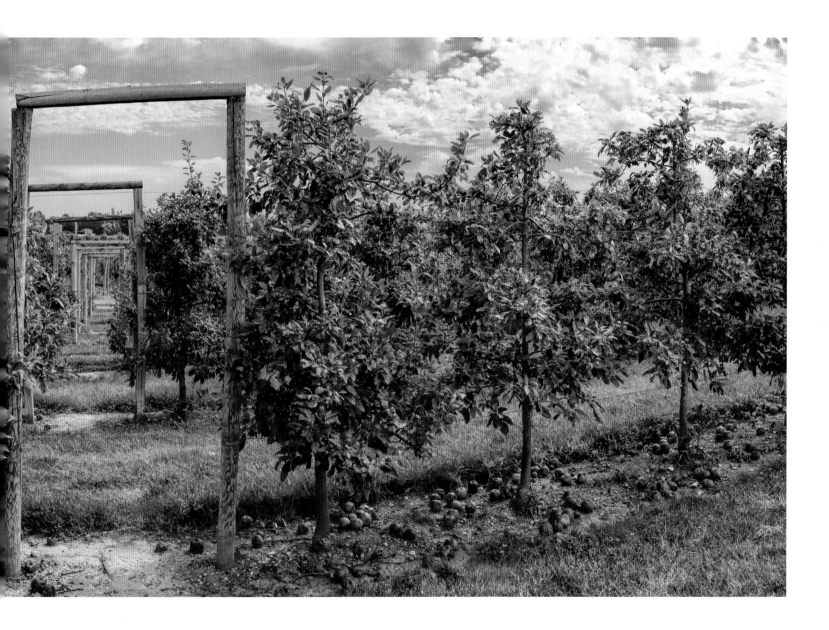

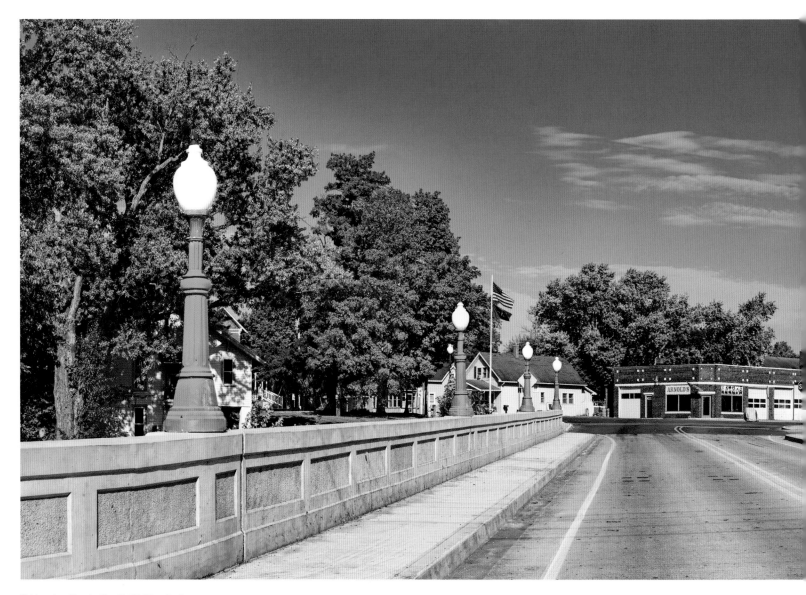

Bridge leading to South Whitley, Indiana

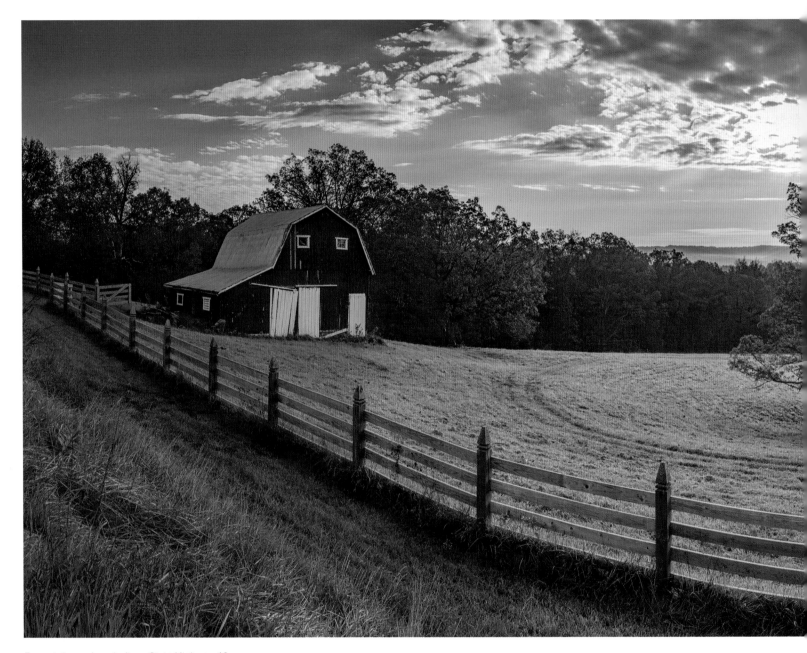

Barn at dawn along Indiana State Highway 46

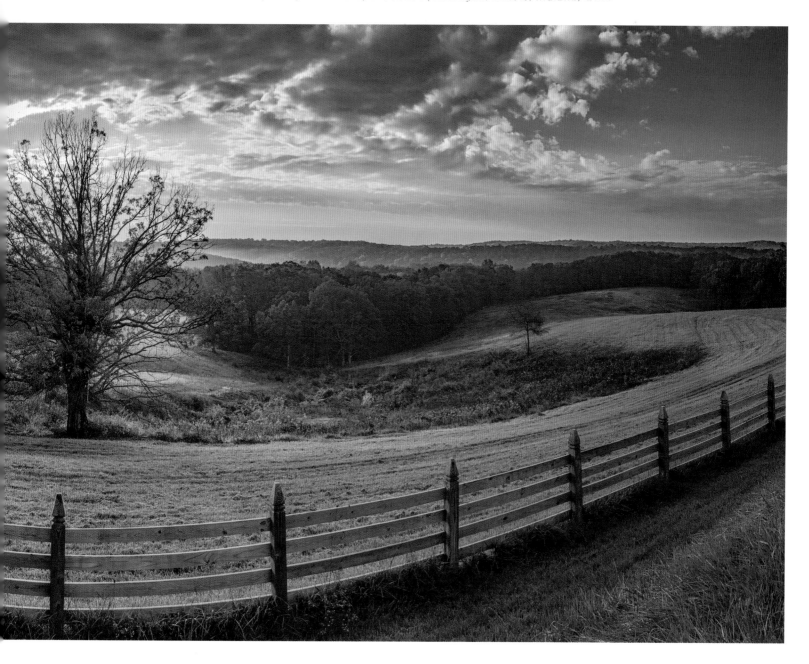

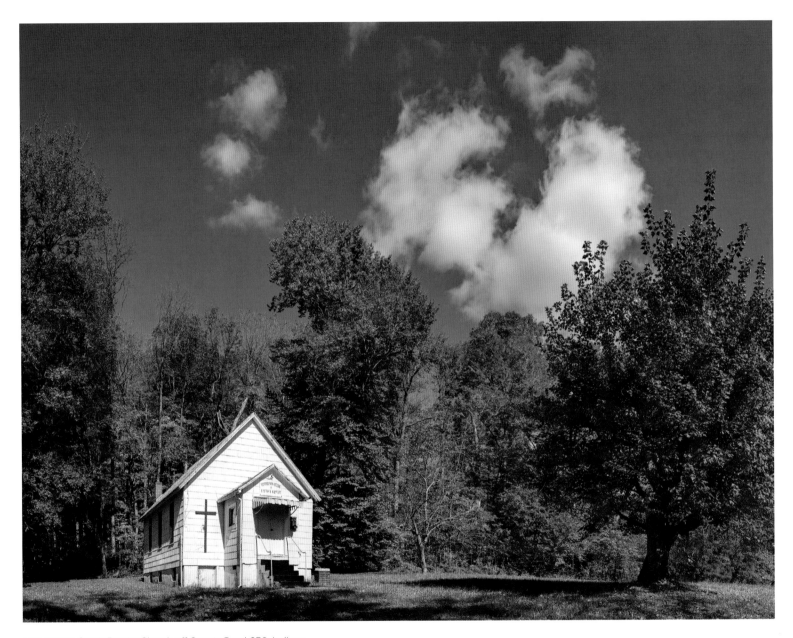

Henderson Creek Baptist Church off County Road 650, Indiana

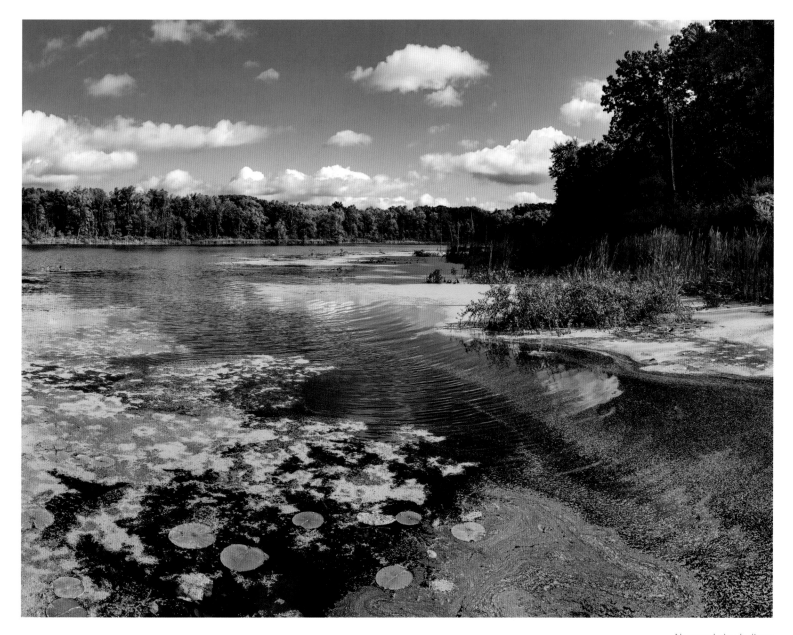

Norman Lake, Indiana

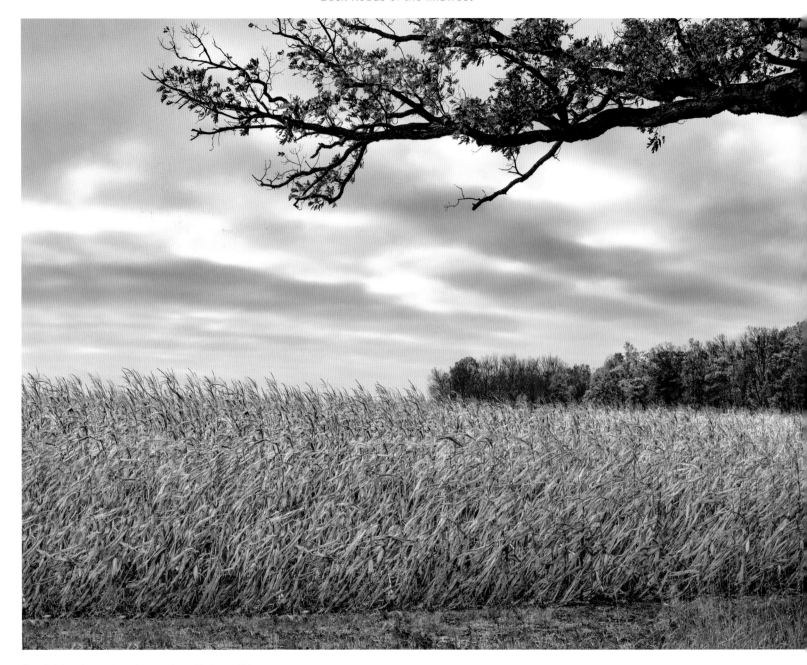

Cornfield and tree along Indiana State Highway 162

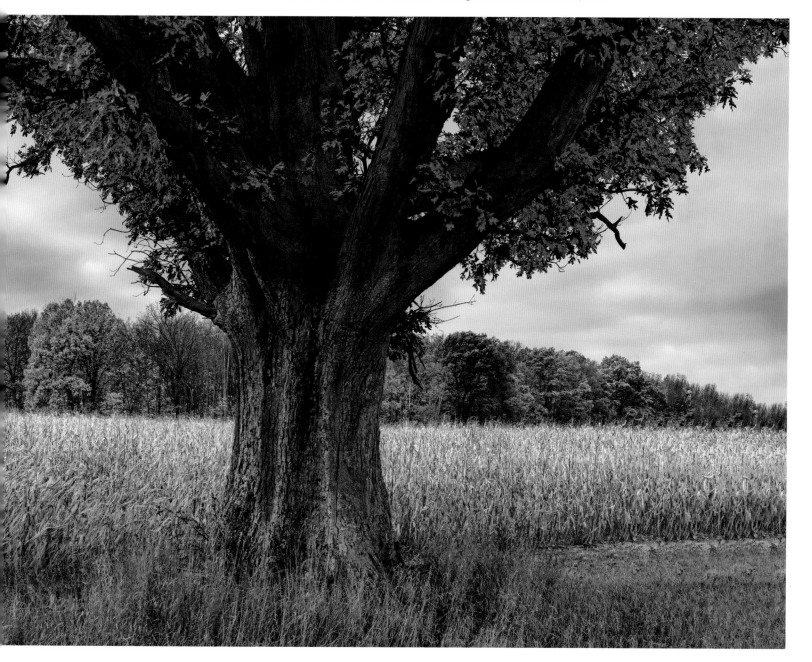

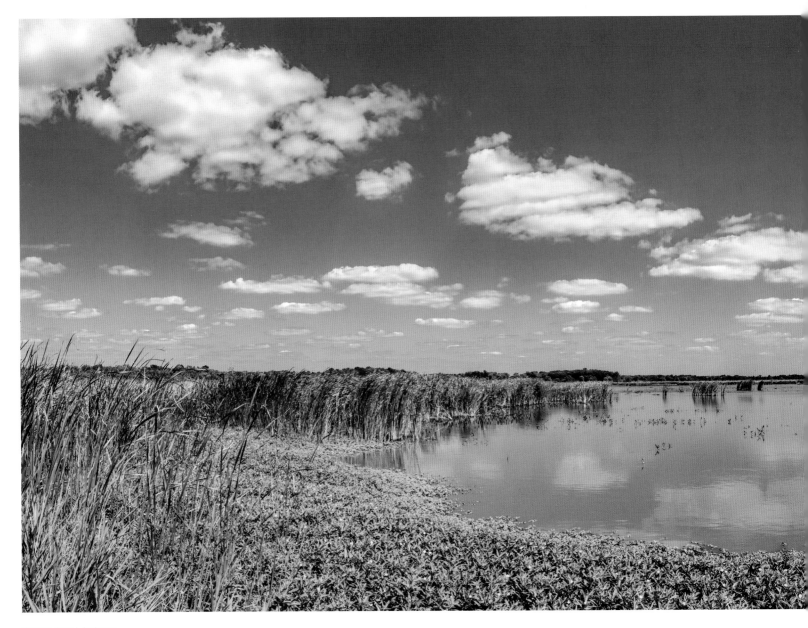

Goose Pond, Indiana

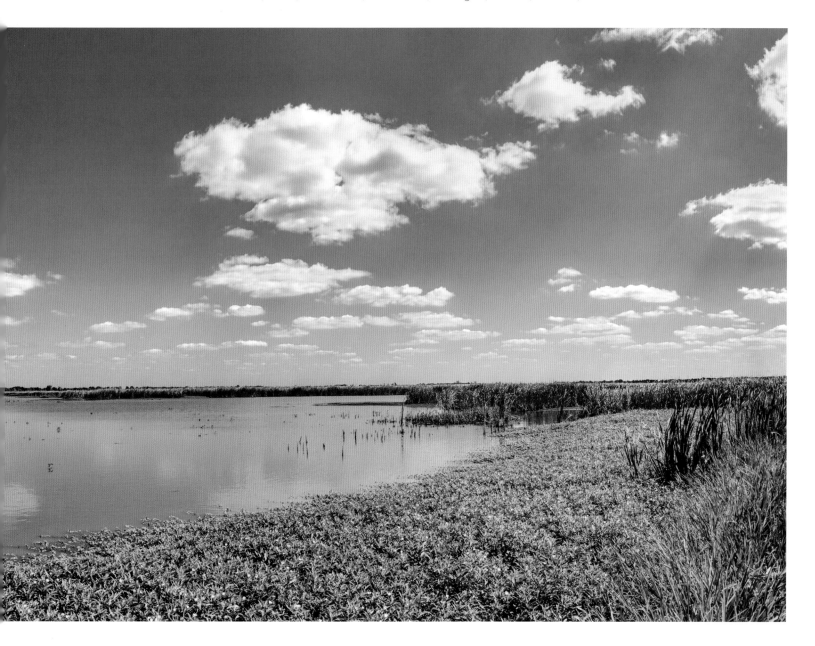

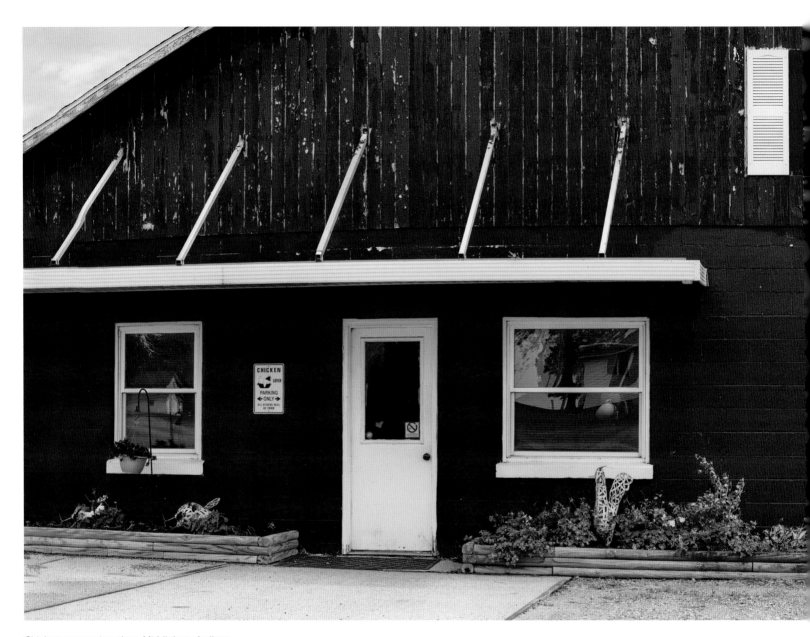

Chicken-processing plant, Middlebury, Indiana

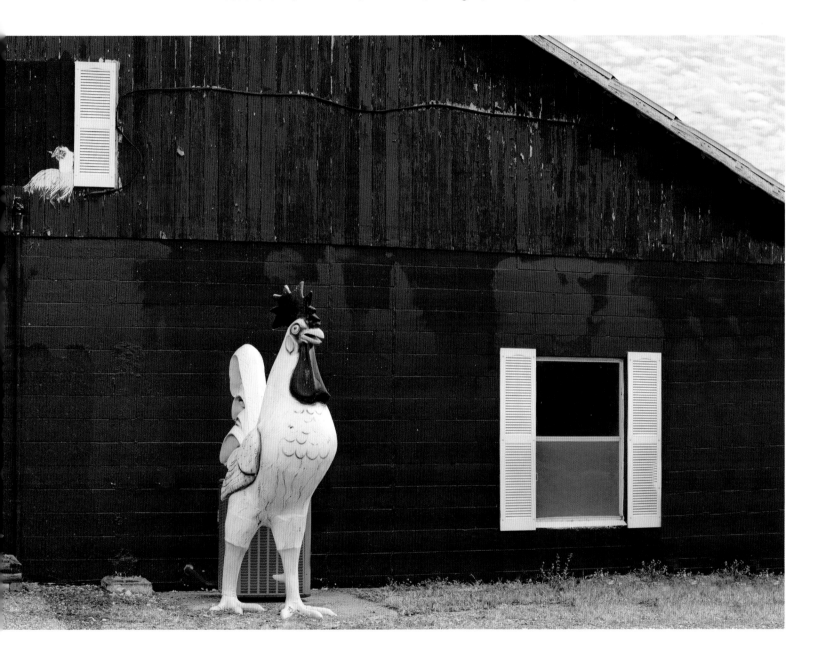

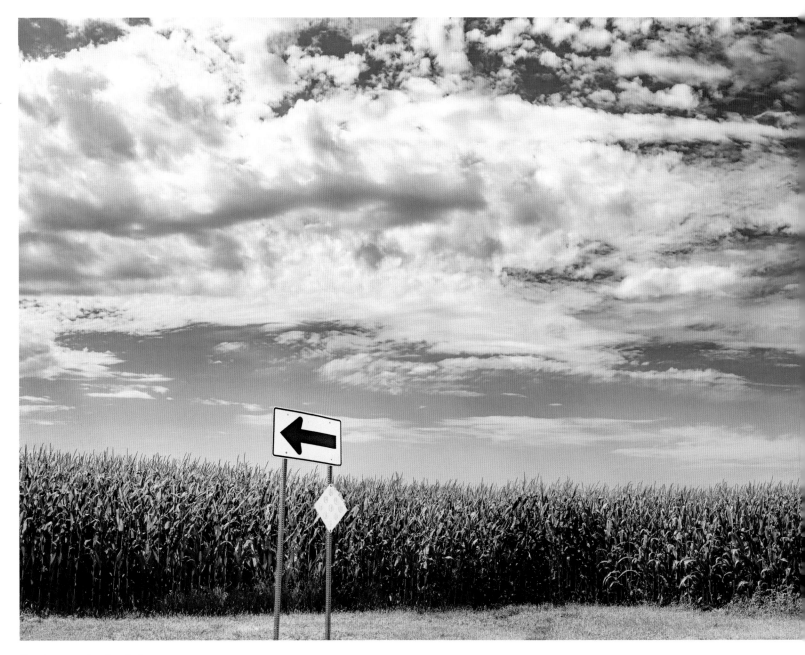

Corn in every direction, Indiana

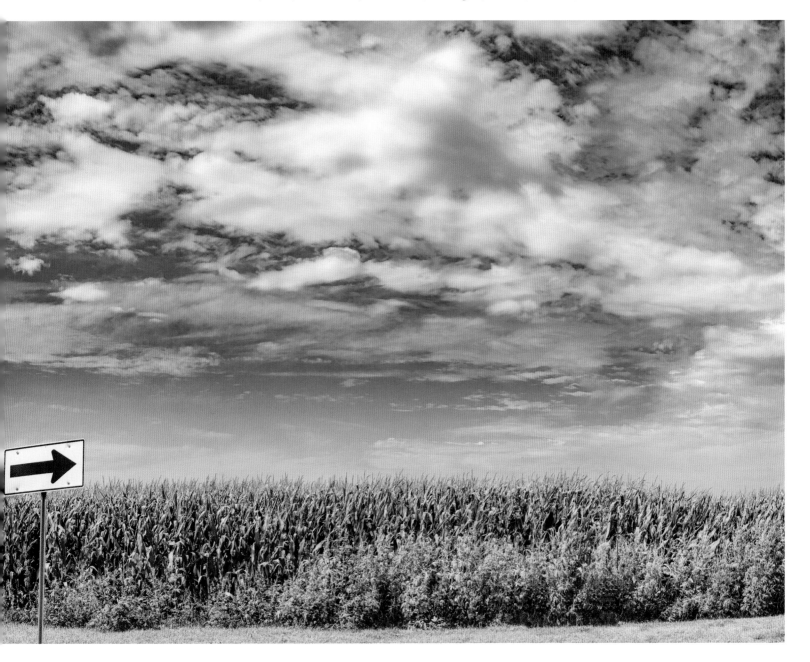

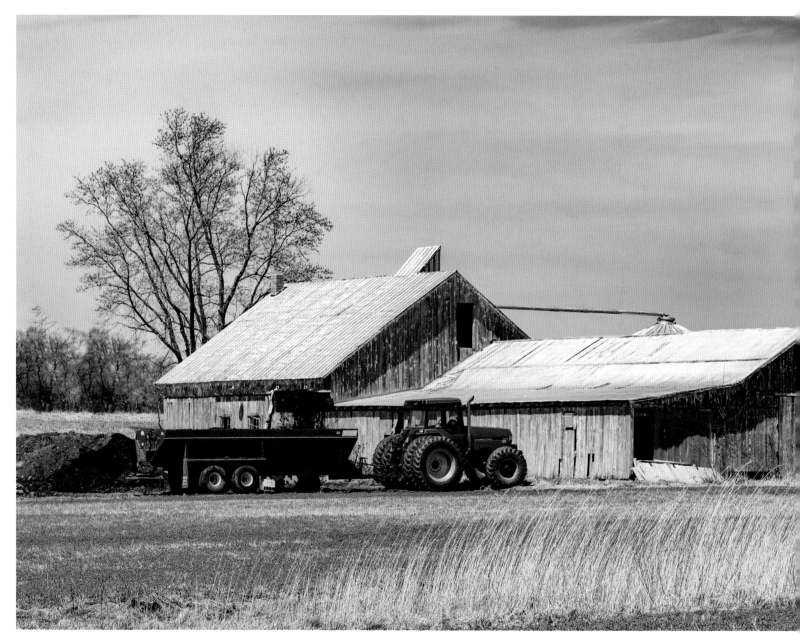

Wildflowers and farm along Indiana State Highway 57

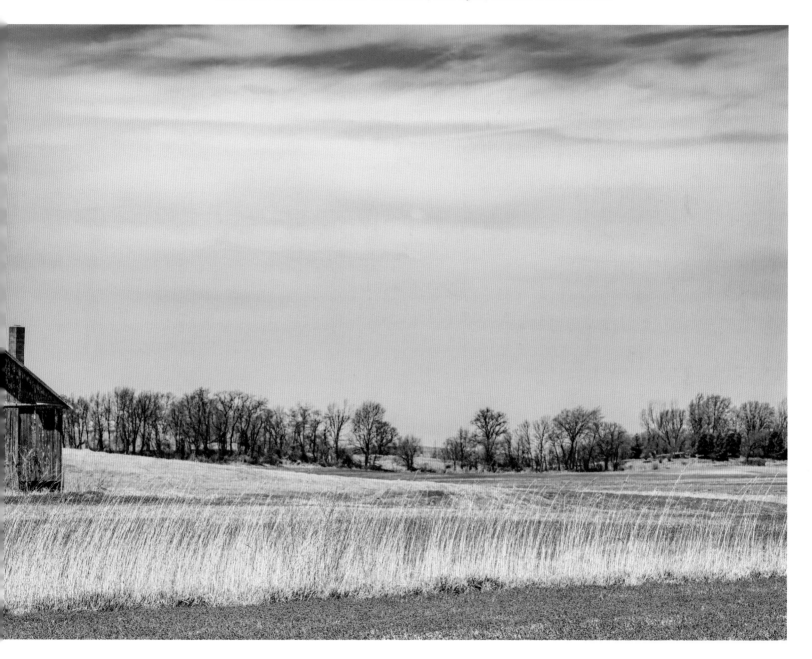

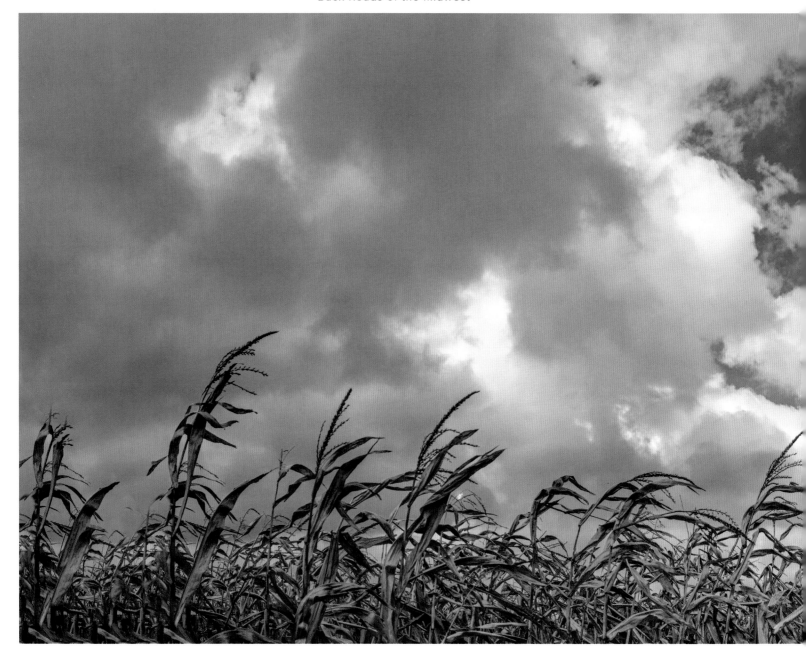

Brick church (1913), Dunkirk, Indiana

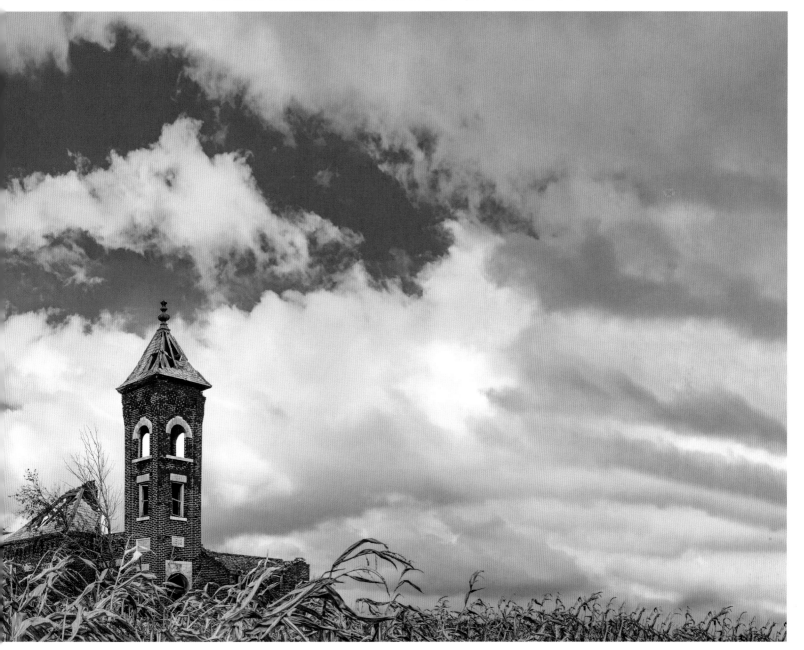

I waited twenty minutes for that cloud to get to that spot.

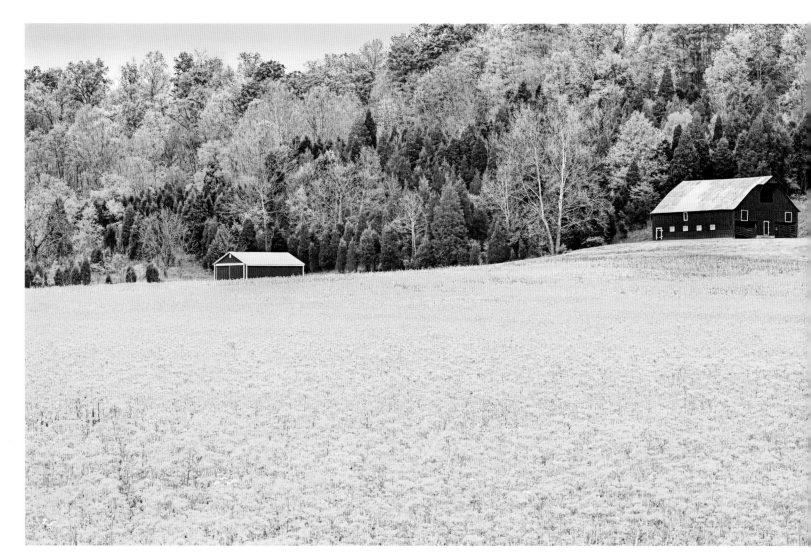

Mustard, Indiana State Highway 37

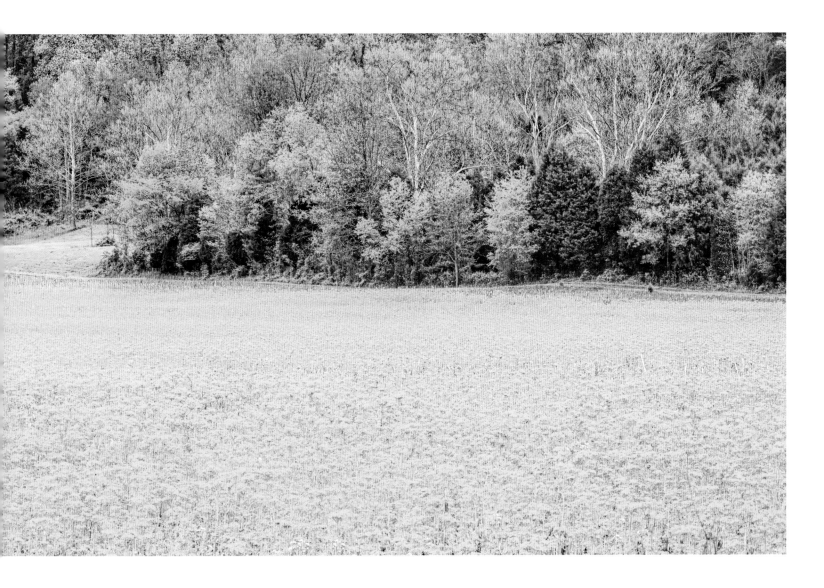

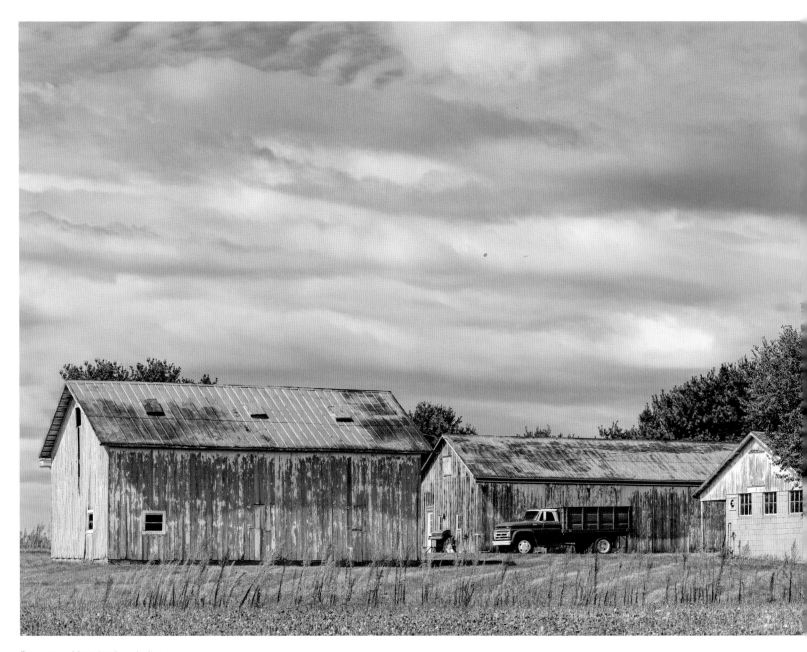

Barns near Maxinkuckee, Indiana

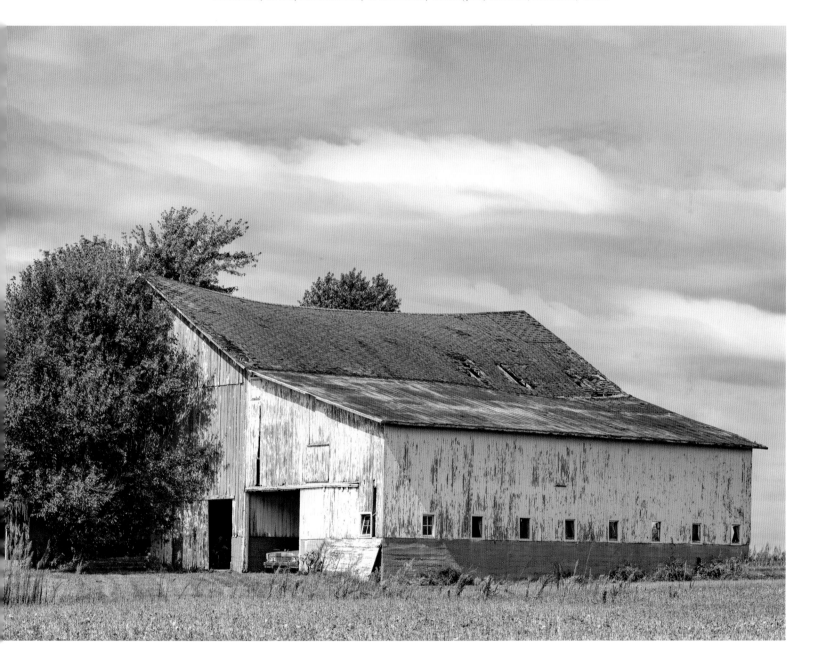

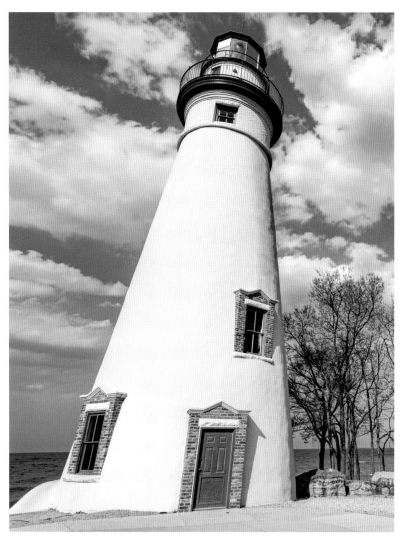

Marblehead Lighthouse, Lake Erie, Ohio

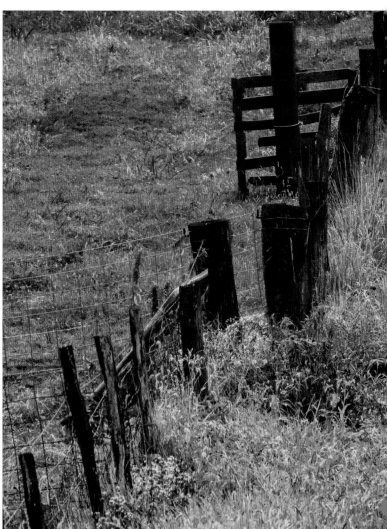

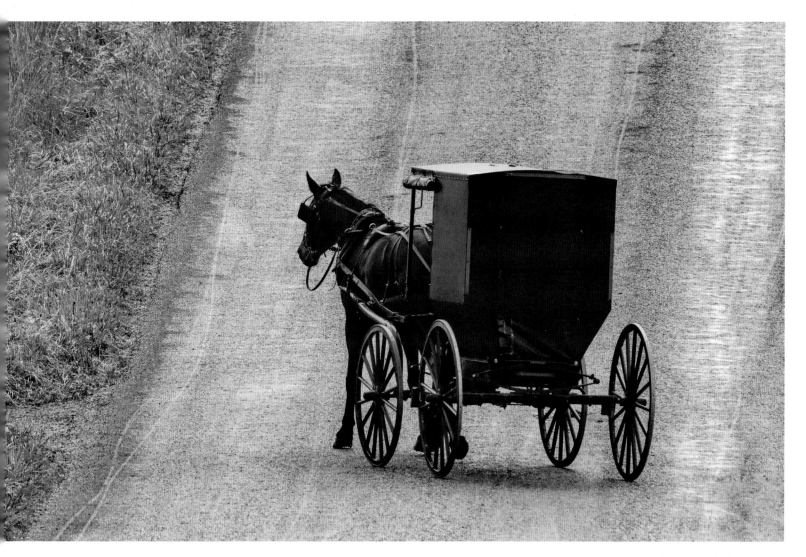

Coming home, Amish Country, Ohio

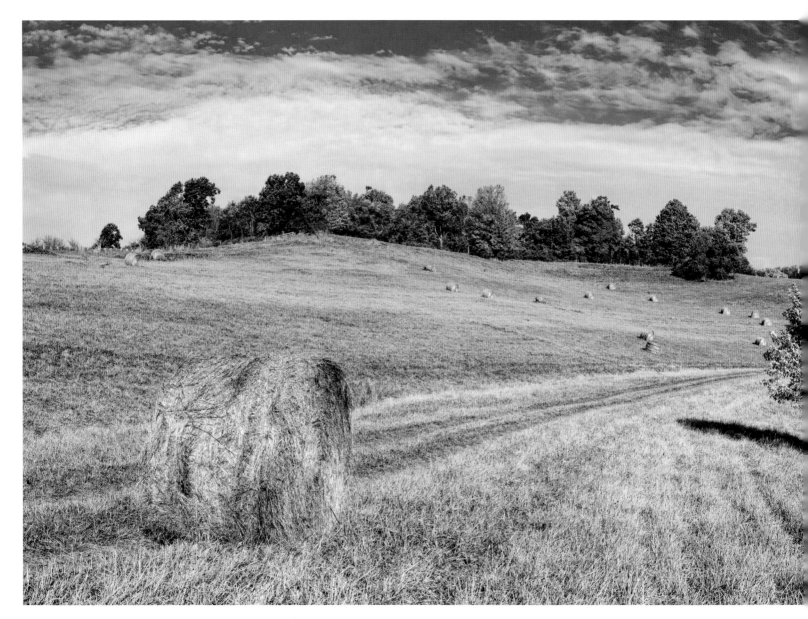

Hayfield, Coshocton County, Ohio

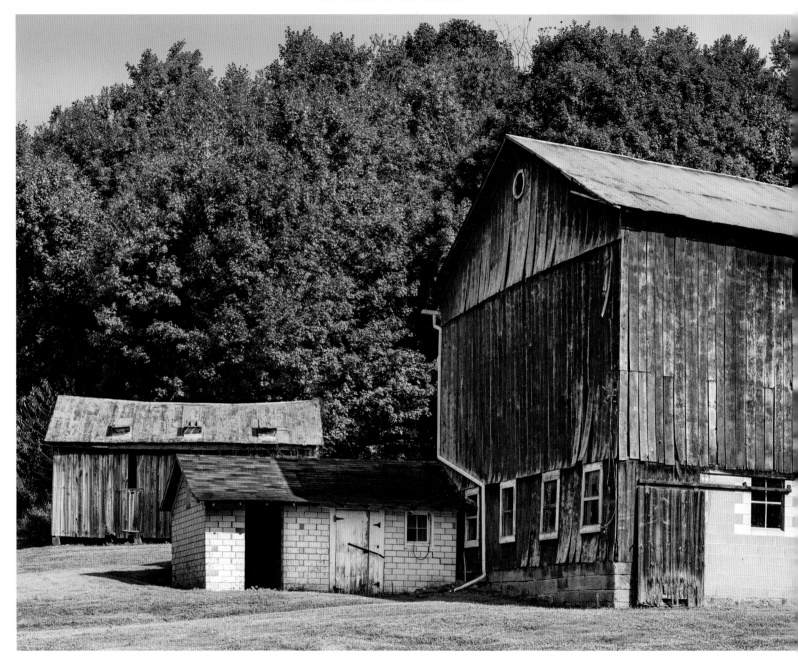

Wall of barns, near Killbuck, Ohio

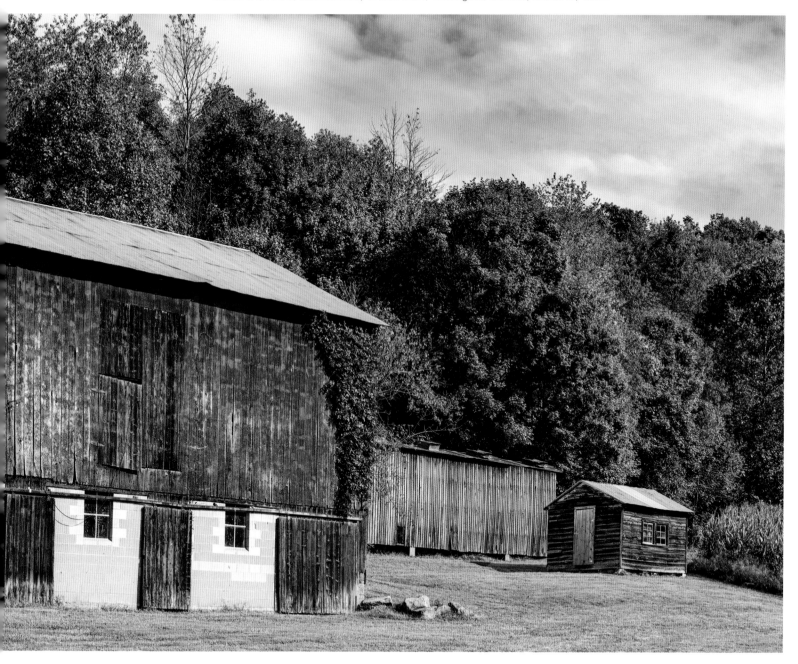

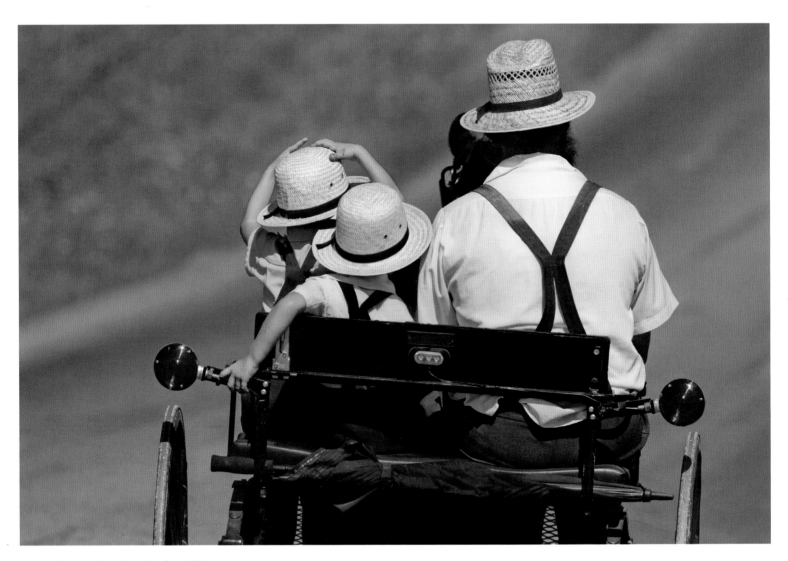

Family riding on Ohio Township Road 601

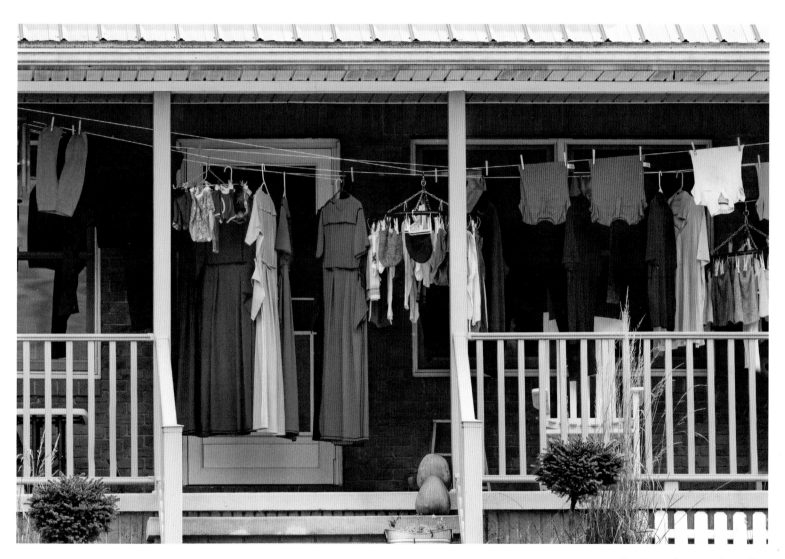

Porch near Fredericksburg, Ohio

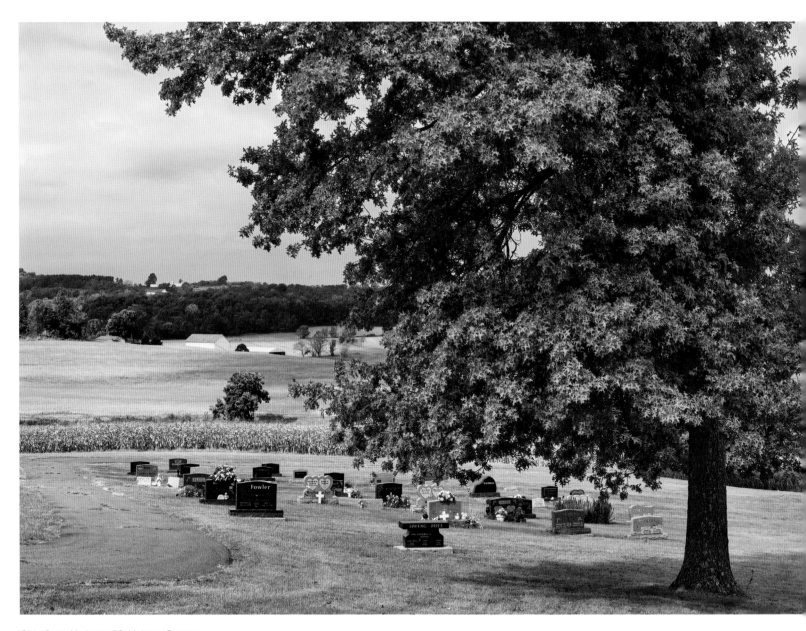

Ohio State Highway 39, Holmes County

Missouri, Iowa, Minnesota, Wisconsin, Michigan, Illinois, Indiana, Ohio

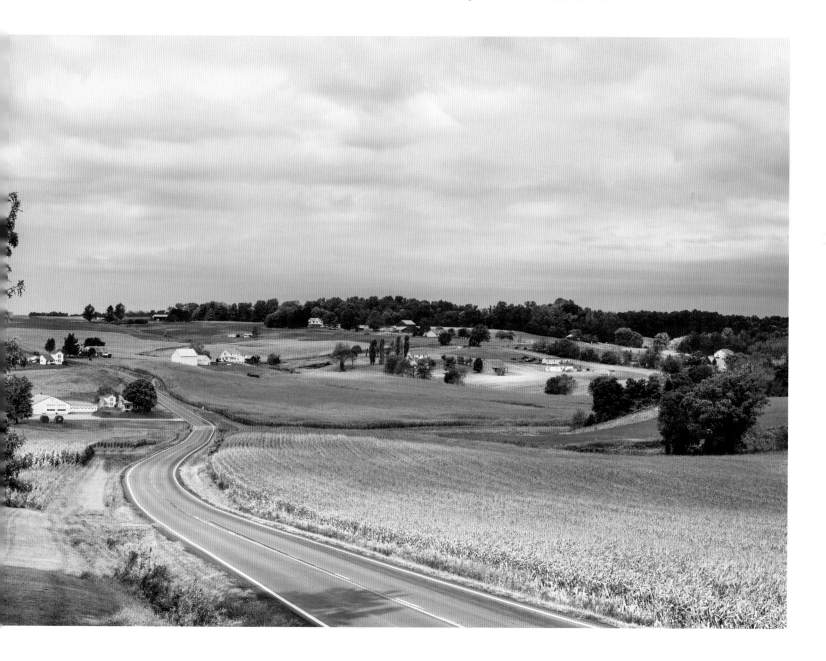

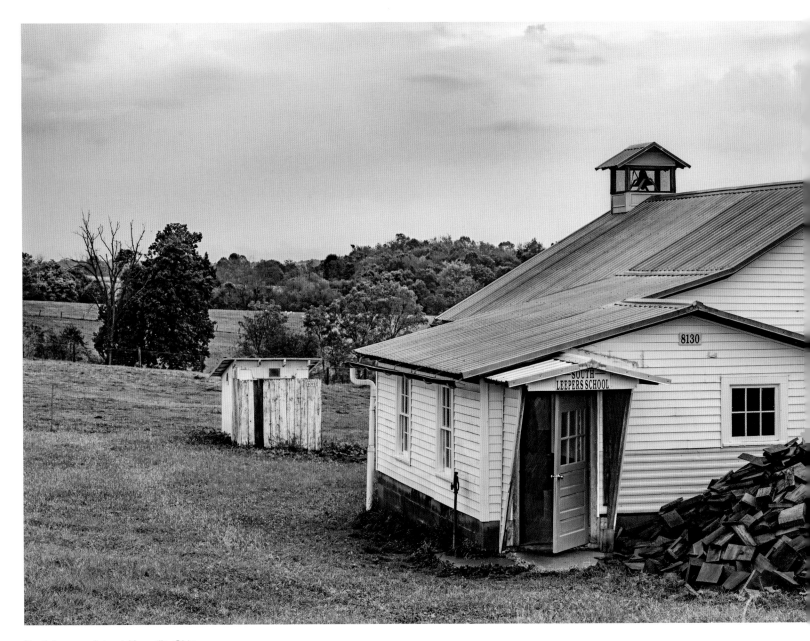

South Leepers School, Maysville, Ohio

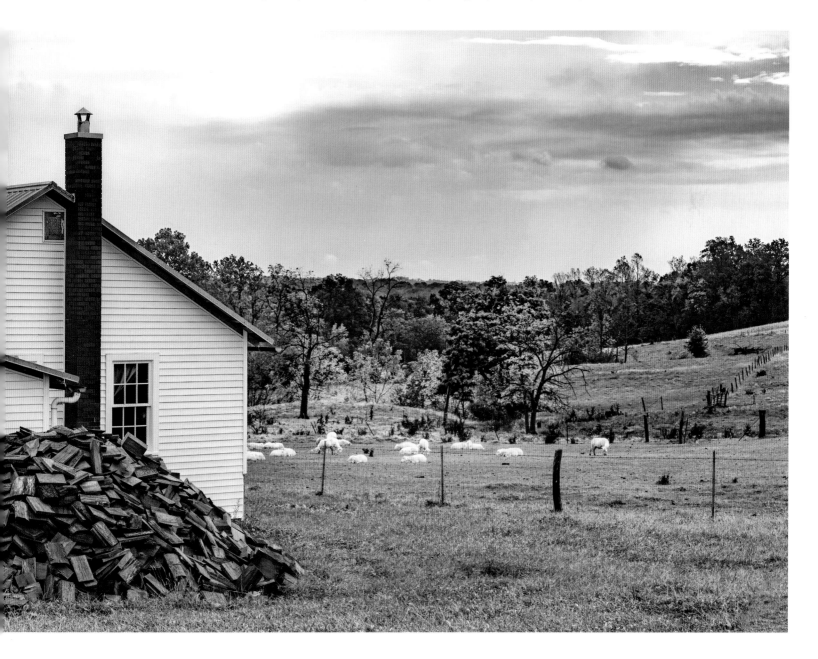

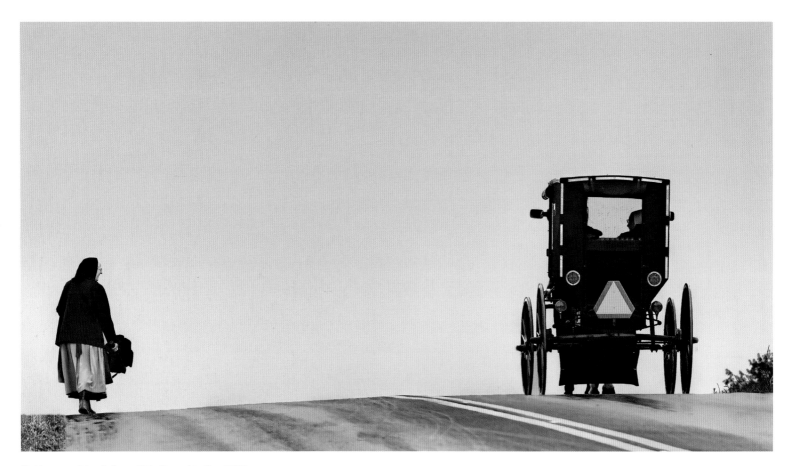

Picking up a friend along Ohio Township Road 835

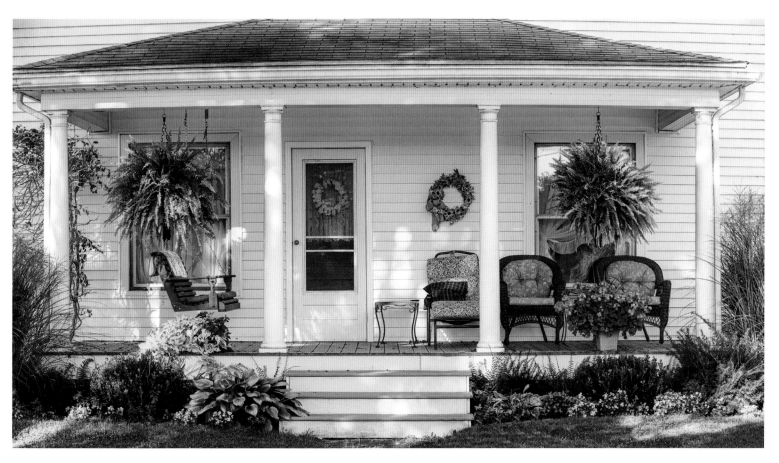

Gordon's porch, West Lafayette, Ohio

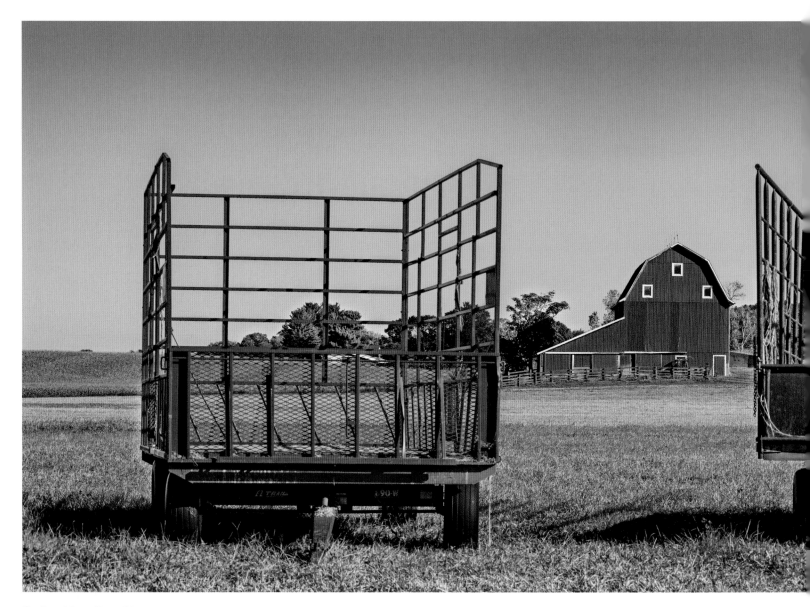

Bluck and Sons Farm, Ohio

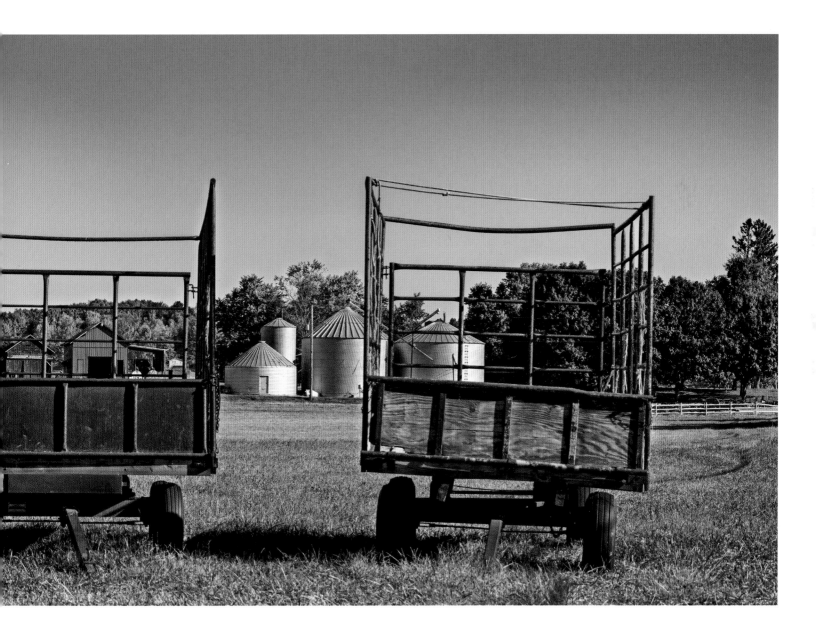

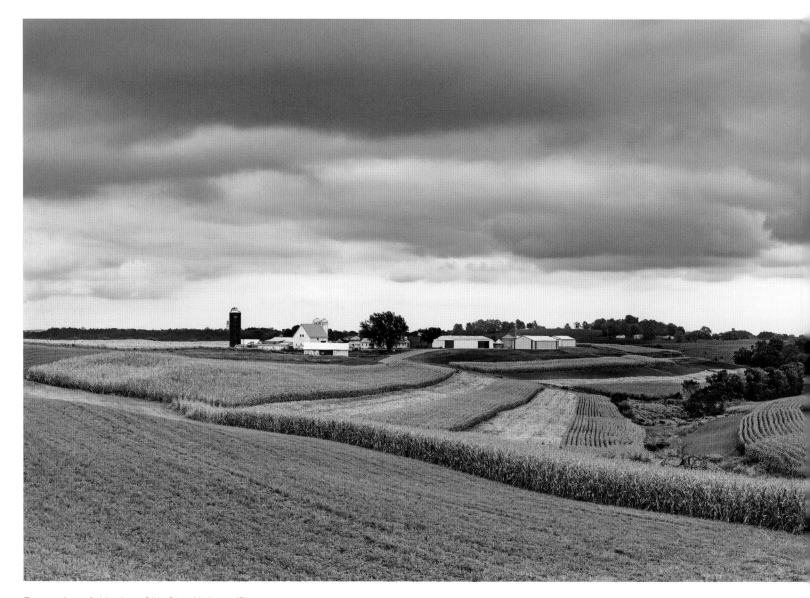

Farm and cornfields along Ohio State Highway 151

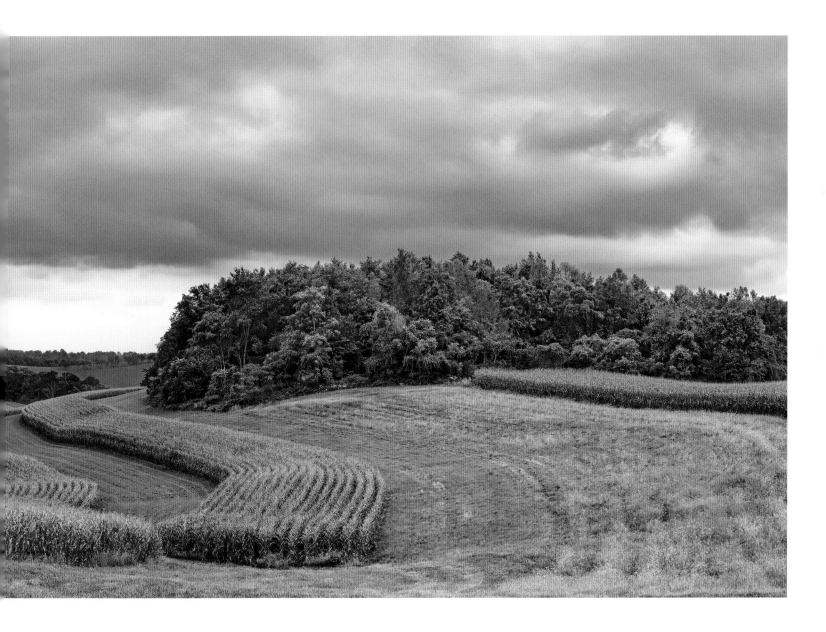

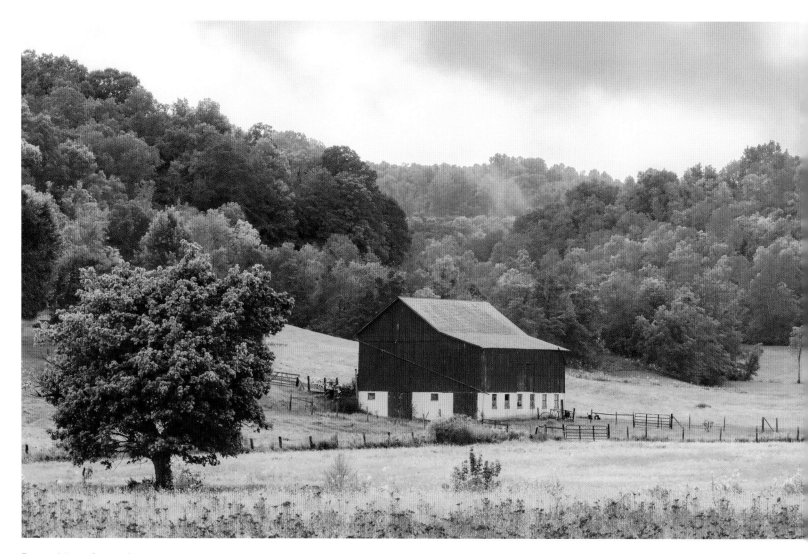

Barn in Athens County, Ohio

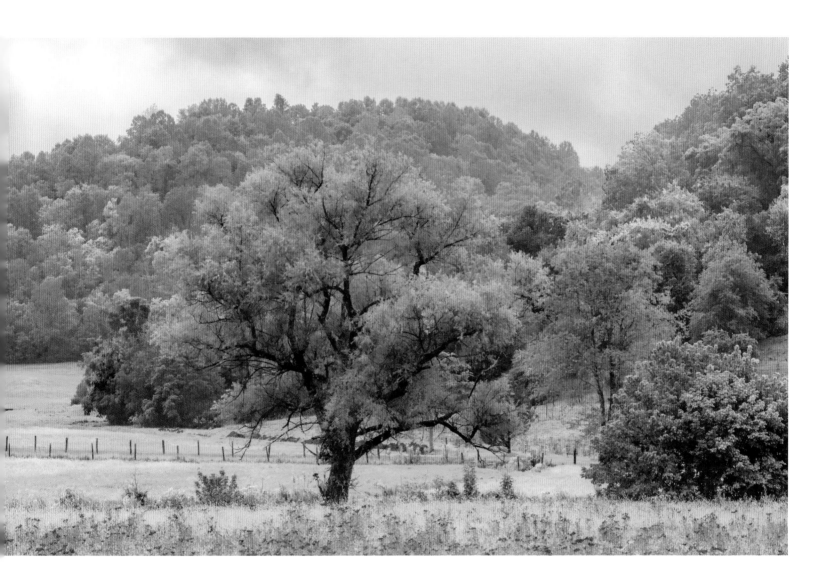

APPENDIX

For all of the photographers out there that love to have all the tech information,
I have included this appendix. May the geeks like me enjoy!

Page	Image Name	Camera	Lens	F/Stop	Shutter Speed	ISO	Pano Image Count	Pano Levels	Dimensions in Inches
6	Old trucks, Missouri	Nikon D810	Nikkor 85mm f/1.8	f/10	1/160	64	7	1	42X17
8	Corn bin, Missouri	Nikon D810	Nikkor 85mm f/1.8	f/11	1/15	64	9	1	50X19
10	Great American Chicken	Nikon D700	Nikkor 35mm f/1.4	f/11	1/320	200	3	1	36X24
11	Davidson Grocery	Nikon D700	Nikkor 35mm f/1.4	f/11	1/320	200	9	1	42X20
12	Hay rolls and barn	Nikon D810	Nikkor 85mm f/1.8	f/13	1/160	64	20	2	67X26
14	Bald eagles	Nikon D500	Nikkor 200-500mm f/5.6	f/8.0	1/3200	1600	n/a	n/a	24X18
15	Railroad bridge	Nikon D810	Nikkor 35mm f/1.4	f/11	2 Seconds	64	16	2	72X56
16	Silos, trucks, and fog	Nikon D850	Zeiss 135mm f/2.0	f/10	1/25	64	6	1	43X20
18	Tree frog	Nikon D810	Nikkor 105mm f/2.5 Macro	f/2.8	1/1600	1000	n/a	n/a	24x16
19	Hangar Kafe	Nikon D810	Nikkor 50mm f/1.4	f/11	1/8	64	20	2	63X39
20	Miller Farms, Missouri	Nikon D700	Nikkor 105mm f/2.5 Macro	f/16	1/125	100	12	1	56X22
22	Great blue heron	Nikon D500	Nikkor 200-500mm f/5.6	f/7.1	1/2000	450	n/a	n/a	24x20
23	Swinging bridge, Missouri	Nikon D810	Nikkor 50mm f/1.4	f/14	1/60	64	8	1	36x20
24	42 Swap Shop and Earl	Nikon D810	Nikkor 50mm f/1.4	f/10	1/400	64	10	1	42X19
26	Four barns	Nikon D810	Nikkor 85mm f/1.8	f/11	1/160	64	8	1	48X19
28	Black Hawk Lake	Nikon D810	Nikkor 50mm f/1.4	f/16	1/40	64	10	1	48X21
30	Graham Road	Nikon D700	Nikkor 35mm f/1.4	f/11	1/50	200	10	1	42X15
32	Wall Lake, Iowa	Nikon D810	Nikkor 85mm f/1.8	f/11	1/400	400	7	1	51X19

Page	Image Name	Camera	Lens	F/Stop	Shutter Speed	ISO	Pano Image Count	Pano Levels	Dimensions in Inches
34	Windswept barn	Nikon D600	Nikkor 85mm f/1.8	f/9.0	1/160	100	17	1	62X16
36	White barns	Nikon D810	Nikkor 50mm f/1.4	f/11	1/250	64	10	1	48X13
38	Iowa turkeys	Nikon D810	Nikkor 50mm f/1.4	f/11	1/250	64	10	1	37X16
40	Crystal Avenue	Nikon D810	Nikkor 50mm f/1.4	f/11	1/250	64	7	1	43X17
42	Saint Paul's Church	Nikon D810	Nikkor 50mm f/1.4	f/9.0	1/160	64	10	1	60X21
44	Two granaries	Nikon D810	Nikkor 50mm f/1.4	f/11	1/100	64	12	1	66X19
46	Mille Lacs Lake	Nikon D750	Nikkor 85mm f/1.8	f/11	1/30	100	16	2	48X19
47	Good Ol' Days Bar and Grill	Nikon D850	Zeiss 135mm f/2.0	f/8	1/80	64	6	1	74X25
48	Early snow	Nikon D810	Nikkor 85mm f/1.8	f/11	1/200	64	8	1	41X18
50	Hayslips Corner Bar	Nikon D850	Nikkor 35mm f/1.4	f/11	3 Seconds	64	8	1	61X24
52	Truck and barn	Nikon D850	Zeiss 135mm f/2.0	f/10	1/15	64	8	1	74X24
54	Cormant Town Hall	Nikon D850	Nikkor 50mm f/1.4	f/8	1/320	64	8	1	64X26
56	Wolf Lake	Nikon D850	Nikkor 50mm f/1.4	f/11	1/320	64	8	1	68X27
58	BNSF and Great Southwest Railroad	Nikon D850	Zeiss 135mm f/2.0	f/8	1/320	64	11	1	76X24
60	Boy River	Nikon D850	Nikkor 50mm f/1.4	f/14	1/40	64	6	1	60X24
62	"Tasha"	Nikon D500	Nikkor 200-500mm f/5.6	f/9.0	1/2500	22800	n/a	n/a	24X16
63	Kawishiwi River	Nikon D810	Zeiss 135mm f/2.0	f/11	1/60	64	14	2	62X41
64	Swan River	Nikon D850	Nikkor 50mm f/1.4	f/13	1/125	20	8	1	66X24
66	Moose calf	Nikon D500	Nikkor 200-500mm f/5.6	f/8	1/2500	1800	n/a	n/a	24X15
67	Silver Creek	Nikon D850	Nikkor 50mm f/1.4	f/10	1/200	64	6	1	48X26
68	Curious Wisconsin cows	Nikon D500	Nikkor 200-500mm f/5.6	F/9.5	1/500	400	n/a	n/a	24X16
69	Algoma Pierhead Lighthouse	Nikon D700	Zeiss 135mm f/2.0	f/5.6	1/350	100	n/a	n/a	24X16

Page	Image Name	Camera	Lens	F/Stop	Shutter Speed	ISO	Pano Image Count	Pano Levels	Dimensions in Inches
70	Sturgeon Bay Lighthouse	Nikon D600	Nikkor 35mm f/1.4	f/13	1/25	200	7	1	42X15
72	Barn and spring trees	Nikon D850	Nikkor 85mm f/1.8	f/9.0	1/125	160	22	2	61X23
74	Red Lake	Nikon D700	Nikkor 85mm f/1.8	f/10	1/250	64	n/a	n/a	24X13
75	View from County Road E	Nikon D600	Nikkor 35mm f/1.4	f/11	1/60	100	7	1	36X20
76	Friendly cows	Nikon D7100	Nikkor 70-200mm f/2.8	f/10	1/500	2500	n/a	n/a	24X16
77	County Road C	Nikon D600	Nikkor 35mm f/1.4	f/11	1/250	200	8	1	44X29
78	Rieck's Lake	Nikon D00	Nikkor 85mm f/1.8	f/13	1/60	100	12	1	61X22
80	Gerndt Bros. Farm	Nikon D750	Nikkor 35mm f/1.4	f/11	1/50	100	9	1	76X32
82	Farm	Nikon D7100	Nikkor 35mm f/1.4	f/11	1/25	100	10	1	60X16
84	Chickens looking dangerous	Nikon D500	Nikkor 200-500mm f/5.6	f/6.3	1/1250	2500	n/a	n/a	24X16
85	Stare-down with a goat	Nikon D7100	Nikkor 70-200mm f/2.8	f/4.0	1/125	100	n/a	n/a	24X16
86	Dairy farm	Nikon D810	Nikkor 50mm f/1.4	f/11	1/160	200	9	1	61X32
88	Kewaunee Street	Nikon D600	Nikkor 85mm f/1.8	f/13	1/250	320	13	1	72X23
90	Lake Huron	Nikon D750	Nikkor 24mm f/2.8	f/13	1/15	100	n/a	n/a	24X24
91	Manitowoc Lighthouse	Nikon D750	Nikkor 105mm f/2.5	f/11	2 Seconds	100	4	1	48X48
92	Fowler Farms	Nikon D750	Nikkor 35mm f/1.4	f/11	1/200	100	7	1	60X25
94	Saint Ignace Light	Nikon D700	Nikkor 70-200mm f/2.8	f/9.0	1/60	100	n/a	n/a	16X24
95	Mackinac Bridge	Nikon D700	Nikkor 70-200mm f/2.8	f/8	4 Seconds	200	n/a	n/a	18X10
96	Eagle Harbor Lighthouse	Nikon D700	Nikkor 35mm f/1.4	f/14	1/60	400	12	1	54X22
98	Fall colors	Nikon D700	Nikkor 70-200mm f/2.8	f/16	1/15	200	n/a	n/a	36X20
99	Trumpeter Swans	Nikon D700	Nikkor 70-200mm f/2.8	f/8	1/250	1600	n/a	n/a	14X22
100	Tahquamenon Falls	Nikon D700	Nikkor 50mm f/1.4	f/16	1/6	100	12	1	68X21

Page	Image Name	Camera	Lens	F/Stop	Shutter Speed	ISO	Pano Image Count	Pano Levels	Dimensions in Inches
102	Whitefish Point Light Station	Nikon D700	Nikkor 70-200mm f/2.8	f/11	1/60	100	n/a	n/a	27X15
103	Whitefish Bay Beach	Nikon D700	Nikkor 35mm f/1.4	f/16	1/6	100	n/a	n/a	16X24
104	Lake Michigan	Nikon D700	Nikkor 85mm f/1.8	f/13	1/6	100	12	1	54X20
106	Port of Grafton Lighthouse	Nikon D700	Zeiss 28mm f/20	f/11	1/320	200	8	1	41X25
107	Illinois River	Nikon D810	Nikkor 50mm f/1.4	f/11	1/160	64	16	2	51X29
108	Tree and barn	Nikon 7100E	Nikkor 35mm f/1.4	f/11	1/40	100	9	1	60X21
110	Truck and silos	Nikon D700	Zeiss 135mm f/2.0	f/10	1/400	100	7	1	54X21
112	Coming storm	Nikon D810	Nikkor 50mm f/1.4	f/9.0	1/160	64	8	1	45X18
114	Horses	Nikon D500	Nikkor 200-500mm f/5.6	f/8.0	1/2000	220	n/a	n/a	24X14
115	Johnson Upholstery	Nikon D810	Nikkor 50mm f/1.4	f/9.0	1/160	64	7	1	33X18
116	Five corn bins	Nikon D810	Nikkor 50mm f/1.4	f/10	1/80	64	12	1	65X19
118	Timberdoodle Trail	Nikon D7100	Nikkor 35mm f/1.4	f/11	1/20	100	11	1	58X20
120	Hay truck	Nikon D750	Nikkor 85mm f/1.8	f/11	1/100	100	8	1	45X15
122	Windmills, cornfields, and barns	Nikon D700	Nikkor 35mm f/1.4	f/11	1/250	100	12	1	60X18
124	White on white	Nikon D810	Nikkor 85mm f/1.8	f/14	1/125	64	8	1	60X20
126	Canada geese	Nikon D500	Nikkor 200-500mm f/5.6	f/8	1/2500	1000	n/a	n/a	24X13
127	Old schoolhouse	Nikon D810	Nikkor 85mm f/1.8	f/13	1/160	64	5	1	67X37
128	Kuipers Family Farm	Nikon D810	Nikkor 50mm f1.4	f/14	1/125	64	11	1	64X20
130	Bridge leading to South Whitley	Nikon D810	Nikkor 85mm f1.8	f/14	1/200	64	7	1	56X19
132	Barn at dawn	Nikon D800	Nikkor 50mm f1.4	f/11	1/160	100	12	1	52X19
134	Henderson Creek Baptist Church	Nikon D600	Nikkor 35mm f/1.4	f/8	1/1000	200	8	1	50X40
135	Norman Lake	Nikon D810	Nikkor 50mm f/1.4	f/13	1/125	64	15	2	42X32

Page	Image Name	Camera	Lens	F/Stop	Shutter Speed	ISO	Pano Image Count	Pano Levels	Dimensions in Inches
136	Cornfield and tree	Nikon D810	Nikkor 50mm f/1.4	f/13	1/60	64	7	1	45X19
138	Goose Pond	Nikon D700	Zeiss 28mm f/2.8	f/13	1/60	100	10	1	46X17
140	Chicken-processing plant	Nikon D810	Nikkor 85mm f/1.8	f/11	1/100	64	7	1	50X19
142	Corn in every direction	Nikon D810	Nikkor 50mm f/1.4	f/11	1/1000	250	16	2	50X19
144	Wildflowers and farm	Nikon D600	Nikkor 35mm f/1.4	f/8	1/125	100	7	1	41X16
146	Brick church (1913)	Nikon D810	Nikkor 50mm f/1.4	f/13	1/125	64	8	1	53X21
148	Mustard	Nikon D700	Nikkor 70-200mm f/2.8	f/11	1/15	200	10	1	66X21
150	Barns near Maxinkuckee	Nikon D810	Zeiss 135mm f/2.0	f/10	1/320	64	7	1	48X18
152	Marblehead Lighthouse	Nikon D300	Nikkor 18mm f/3.5	f/13	1/60	100	n/a	n/a	20X24
153	Coming home	Nikon D500	Nikkor 200-500mm f/5.6	f/8	1/1600	500	n/a	n/a	36X17
154	Hayfield	Nikon D810	Nikkor 50mm f/1.4	f/14	1/50	64	9	1	54X19
156	Wall of barns	Nikon D810	Nikkor 85mm f/1.8	f/10	1/100	64	8	1	50X19
158	Family riding on Ohio Township Road 601	Nikon D500	Nikkor 200-500mm f/5.6	f/8	1/2000	320	n/a	n/a	24x16
159	Porch near Fredericksburg	Nikon D500	Nikkor 200-500mm f/5.6	f/8	1/1000	2500	n/a	n/a	24x16
160	Ohio State Highway 39	Nikon D810	Nikkor 85mm f/1.8	f/11	1/125	64	7	1	56X20
162	South Leepers School	Nikon D810	Nikkor 85mm f/1.8	f/11	1/60	64	6	1	43X16
164	Picking up a friend	Nikon D500	Nikkor 200-500mm f/5.6	f/8	1/1600	320	n/a	n/a	23X13
165	Gordon's porch	Nikon D810	Zeiss 135mm f/2.0	f/10	1/80	64	6	4	37X20
166	Bluck and Sons Farm	Nikon D810	Zeiss 135mm f/2.0	f/13	1/125	64	7	1	44X15
168	Farm and cornfields	Nikon D750	Nikkor 85mm f/1.8	f/10	1/60	100	12	1	48X16
170	Barn in Athens County, Ohio	Nikon D700	Nikkor 85mm f/1.8	f/11	1/25	100	9	1	72X22

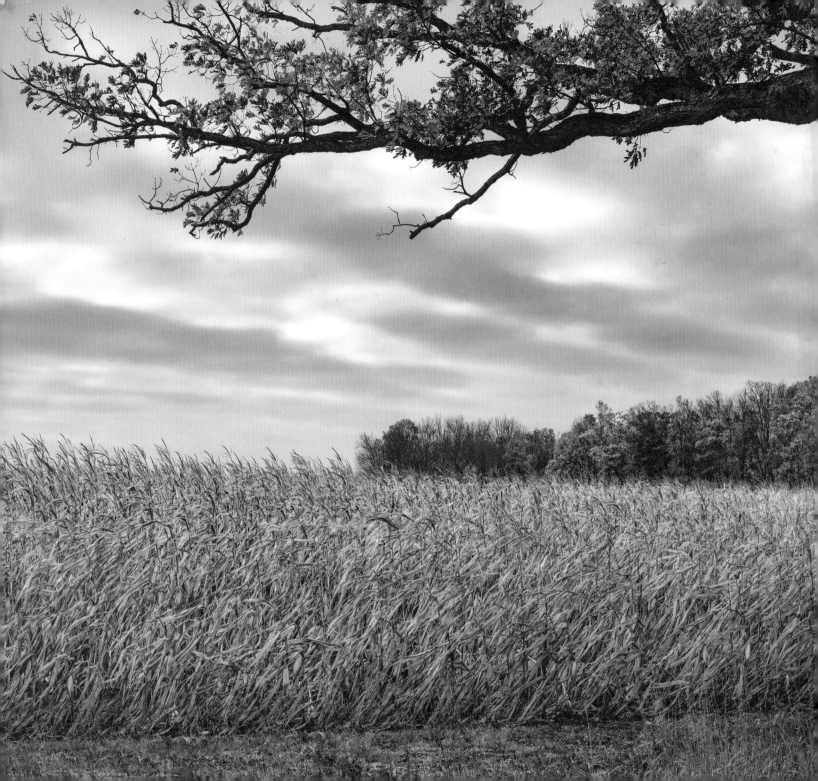